The
Seduction
of Curves

The Seduction of Curves

THE LINES OF BEAUTY THAT CONNECT MATHEMATICS, ART, AND THE NUDE

Allan McRobie

WITH PHOTOGRAPHY BY HELENA WEIGHTMAN

Princeton University Press
Princeton and Oxford

Published by Princeton University Press, 41 William Street, Princeton, New Jersey 08540

In the United Kingdom: Princeton University Press, 6 Oxford Street, Woodstock,

Oxfordshire OX20 1TR

press.princeton.edu

Jacket photograph by Helena Weightman

Library of Congress Cataloging-in-Publication Data

Names: McRobie, Allan | Weightman, Helena.

Title: The seduction of curves : The lines of beauty that connect mathematics, art, and the nude / Allan McRobie ;
with photography by Helena Weightman.

Description: Princeton : Princeton University Press, [2017] | Includes bibliographical references and index.

Identifiers: LCCN 2016046344 | ISBN 9780691175331 (hardback : alk. paper)

Subjects: LCSH: Curves. | Curves in engineering. | Geometry, Plane. | Shapes. | Form (Aesthetics)

Classification: LCC QA483 .M37 2017 | DDC 516/.152—dc23 LC record available at https://lccn.loc.gov/2016046344

British Library Cataloging-in-Publication Data is available

This book has been composed in Garamond Premier Pro Light Display

Printed on acid-free paper. ∞

Printed in the Czech Republic

1 3 5 7 9 10 8 6 4 2

Contents

A more aesthetic notion than the latest theory of Catastrophes by René Thom is still to be found, . . . [it] has bewitched all of my atoms since I first heard about it.

Salvador Dalí, 1985, possibly his last words on the subject of art

Acknowledgments

This book first emerged during a fellowship I received in 2003 from the UK's National Endowment for Science, Technology, and the Arts (NESTA). I had proposed to investigate how engineering interacted with wider aspects of humanity, such as justice, beauty, equity, values, and capabilities. I would look at the societal impact of bridges, the mathematics of belief and of values, and I would also restore the Cambridge Phillips Machine—a 1950s water computer that endeavors to model human economic decision making. However, toward the end of the fellowship, a fourth theme emerged unexpectedly—the set of ideas that I lay out in this book. I am thus extremely grateful to Venu Dhupa, to NESTA, to Keith Glover, and to my mentor Libby Purves for giving me the freedom to chase these ideas, and for their support throughout.

As the book emerged, I had fruitful discussions with many people. Foremost amongst these are Issam Kourbaj and Paul Kirby, who added crucial insights at the very beginning. I am also grateful for discussions with Andrew and Jane Palmer, Barry Phipps, Sarah and Mark Wormald, Caroline Lambard, Grace Adam, and many others.

I greatly appreciate the recent feedback and the added insights provided by Michael Berry who—although he does not remember—taught me much of the underlying mathematics when I was a young student at Bristol University in the 1970s. I am likewise grateful to Michael Thompson who taught me everything I know about structural stability.

It has been a delight to work with Helena Weightman. Helena provided not only the stunning photography but many key insights and ideas. I am grateful also to the many models we worked with: Gestalta, Rebecca, Joel, Gabriel, Ruth, and many more.

My biggest thanks, though, must go to Vickie Kearn at Princeton University Press, who has kept faith in this project and has steered it from its first woolly, wordy ideas to its final appearance as this book, and I shall always be indebted to Steve Strogatz for introducing us. I am grateful to Princeton University Press and to all the people I worked with there. Lauren Bucca was a joy to work with and I am so grateful for her huge and diligent efforts on every level, particularly regarding image rights. I am also thankful to Dimitri Karetnikov, Lorraine Doneker, and Mark Bellis in particular, and to Jenn Backer.

Finally, I thank my wife Helen and my children Fiona, Heather, Ellen, and Charlie for their continued love and support of me in this, throughout this, despite this, and in everything.

Allan McRobie, Cambridge, June 2017

The Alphabet of Beautiful Curves

Curves are seductive. They have an attractiveness and an appeal that straight lines and square corners cannot invoke. Curves are the lines of beauty that speak to us on some deeply instinctual level.

And curves have a language, an alphabet, a lexicon. There is, as it were, a periodic table of curved shapes. The modest aim of this book is to illustrate this language, to reveal its inner workings, its syntax, and its grammar. The soaring ambition, though, is to change the way you see the world. These shapes have been on the back of our eyes since birth, yet few have noticed them, let alone observed their nuances. My intention is to bring these shapes to your attention in such a way that henceforth you will never be able not to notice them.

There will be no difficult equations or arcane theorems, even though such equations and theorems exist and give rigor to the theory. The approach will be largely pictorial, and the pictures will, I hope, be interesting. The body of mathematics that we shall draw on is known as catastrophe theory (or singularity theory), and it is largely the creation of the maverick French mathematician René Thom (1923–2002).[1] It is a branch so magical it can—according to Salvador Dalí—bewitch all of your atoms.

In 1958, Thom was awarded the highest prize in mathematics, the Fields Medal, for his contributions to topology, work he developed in his doctoral thesis, which was completed when he was only twenty-eight. Topology is an abstract branch of mathematics devoted to smooth, stretchy shapes. In the years that followed the Fields Medal, Thom went on to create catastrophe theory, the branch of mathematics that underlies this book. The stimulus for this work was Thom's interest in the shapes of nature and this question: Why are things shaped the way they are? Biological forms were the main focus of interest, but sources of inspiration included the dancing patterns created by light reflecting from raindrops.

Many books have sought to build links between mathematics and art, exploring topics such as symmetry, proportion, perspective, tessellations, and polyhedra. The theories have almost invariably been built using straight-line geometry, with some even seeking to explain beauty using the aspect ratio of a particular rectangle, a rectangle they call "Golden" no matter what color it is. It does not matter how much you say about $(1 + \sqrt{5})/2$, to me it is just a rectangle, and I think there are far more beautiful shapes in the world.

But while it is undeniable that straight-line geometry has many applications in science, in art, and in architecture, there is a rich—indeed arguably richer—set of shapes where straight-line geometry is of little use. This is the world of curvature. And not the pristine curved shapes of classical geometry like the sphere, the cylinder, and the cone. In this book, the focus is on the smooth irregular blob, the organic form.

The human body, the cell, and the space-time fabric of the Universe are just three examples of irregular, smoothly curved surfaces that give a first intimation of how important a theory of curved shape may be. As we shall see, the theory has even wider application. In engineering, this language explains how building columns collapse and oil rigs capsize. In astronomy it allows distant galaxies far across the Universe to be weighed, and it aids the discovery of earth-like planets around stars other than our own. And almost magically, it also has something to say about the rainbow, the twinkles on a sunlit sea, and the beautiful patterns of light that dance on the sides of boats in Mediterranean harbors.

As children we are taught a geometrical sequence beginning

triangle, square, pentagon, hexagon,…

It is an alphabet applicable to straight-line Euclidean geometry. René Thom, however, pointed out that there is another alphabet appropriate for curved geometry, and it contains the sequence

fold, cusp, swallowtail, butterfly,…

This sequence is known as the *cuspoids*, and these first four elements, together with the first three elements of another sequence, the *umbilics*, comprise Thom's famous Seven Elementary Catastrophes. They are "elementary" in the same sense as the chemical elements, in that they are the basic building blocks, the fundamental components of curved form. Thom's "elements" of shape can be combined to create more complex "molecules" of form.

On first inspection, Thom's alphabet may appear paradoxical. The first object, the fold, may be rather unsurprising—it looks like an arch, curving in one direction only. However, the second object—the cusp—and all the higher-order elements are spiky. Such spikes may seem strange in an

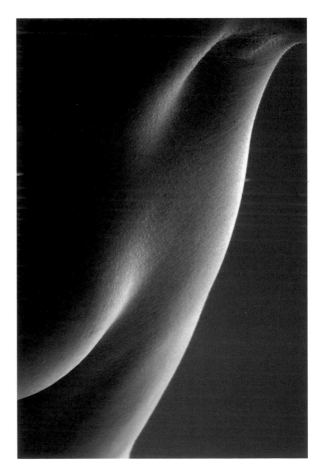

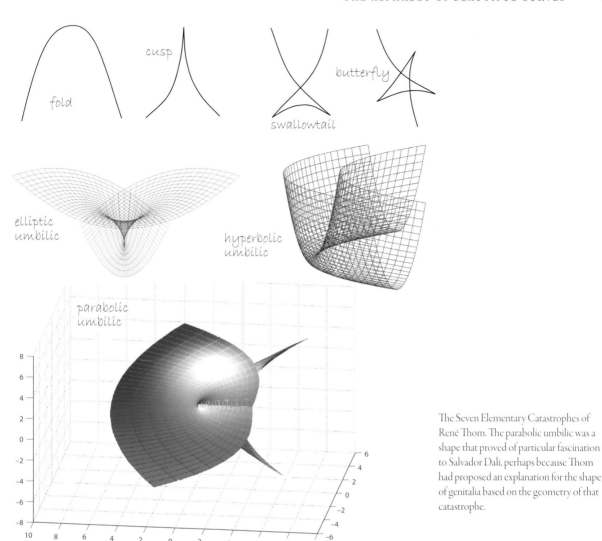

fold

cusp

swallowtail

butterfly

elliptic umbilic

hyperbolic umbilic

parabolic umbilic

The Seven Elementary Catastrophes of René Thom. The parabolic umbilic was a shape that proved of particular fascination to Salvador Dali, perhaps because Thom had proposed an explanation for the shape of genitalia based on the geometry of that catastrophe.

alphabet supposedly applicable to smoothly curved shapes. Perhaps a more natural contender for the second letter would seem to be an S—the doubly curved shape that was bestowed with the title the Line of Beauty by the eighteenth-century British artist William Hogarth. Or perhaps some sort of spiral. And perhaps there should be a squiggle, as on the first pages of *Pedagogical Sketchbook*, the text on the nature of lines and the processes of seeing and drawing by one of the twentieth century's greatest artists, Paul Klee. However, Thom is right. Unlikely as it may seem, the spiky shapes are

the natural elements of curved grammar, as the following chapters will explain.

As well as being a shape, pure and simple, each of the little diagrams can also represent a way by which something can suddenly change. This is highly relevant in engineering, where that sudden event could be a catastrophic collapse. "Catastrophe" comes from the Greek, the final turning point in a tragedy, and in engineering the curved and spiky lines form the "boundaries of stability" beyond which lie tragedy and disaster.

Many years ago I was a bridge designer in Australia, but I am now a lecturer in structural engineering at Cambridge University. One of my courses is on stability theory—a subject of crucial importance for anyone wishing to design bridges—and my lecture notes are full of curvy, spiky, squiggly diagrams. A few years ago—and for too many positive reasons to list here—I decided to introduce life drawing classes to the Engineering Department, and so the services of a local artist, Issam Kourbaj, were engaged. Late in the afternoon, each Friday, Issam would bring along his own extraordinary talent, a different view of the world, and a model. It was during one of these highly enjoyable classes that a penny suddenly dropped—the charcoal curves that I was so contentedly drawing on my sketch pad were speaking the same language as the curves I had drawn on the blackboard in that very room earlier in the day in my stability lectures. The sudden and happy recognition that there was a link between two seemingly disparate spheres, between the carefully considered calculations of engineering and the altogether freer activity of making charcoal marks on paper, was an unexpected bridge that seemed worthy of further exploration. This book is the result.

Klee's *Sketchbook* begins:

An **active** line on a walk, moving freely, without goal. A walk for a walk's sake.[2]

Perhaps that is one way to think about this book.

Lines from Paul Klee, *Pedagogical Sketchbook* © 2017 Artists Rights Society (ARS), New York (London: Faber and Faber, 1953).

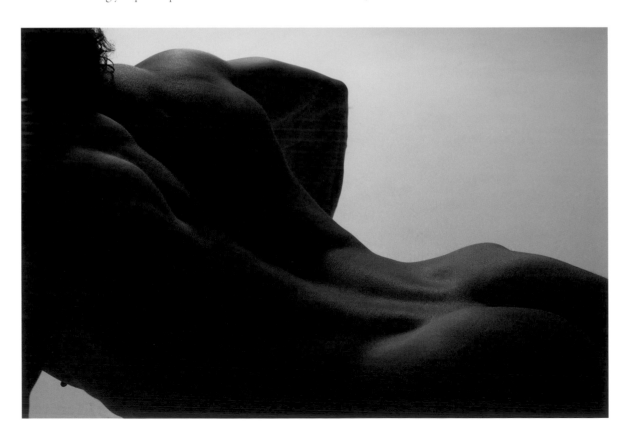

The Fold

As well as being the simplest catastrophe, the fold is also the most common, the one you are most likely to meet.

To introduce the fold, we head to the life drawing class. It may seem unlikely, but the life class is an excellent place to learn catastrophe theory. The purpose of our visit there is twofold. Not only is it a good place to learn the mathematics of curved shape, but in so doing, in unpicking the geometry of the life class, we may learn something more about the act of drawing, about how we perceive the model, and about how we go about representing the body with lines on paper. We may even learn something about the process of perception itself.

Let's start at the very beginning, as they say, with the simplest of all the catastrophes, the fold. It is just a parabola, as sketched to the right. The parabola there has been drawn on its side—it does not matter which way up or which way around you draw it. The point of catastrophe, the turning point, the fold itself, has been highlighted with a dot, and the curves above and below it have been drawn as solid and dotted lines, respectively, to signify that there is usually something different about the two parts of the curve that meet at this special point.

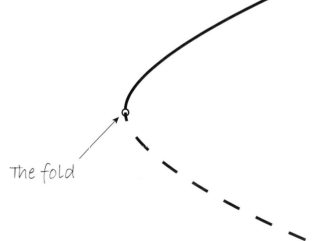

The fold

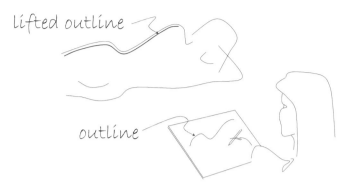

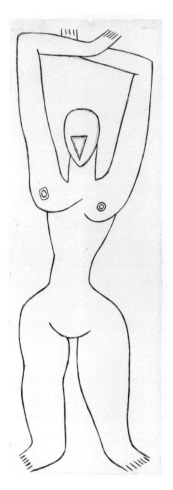

Female Nude, Henri Gaudier-Brzeska. "Hooray!" said the nude. "At last, a bit of understanding."

Imagine that a student in a life class has drawn the outline of the model onto a sketch pad. Imagine also that the teacher, in a break from normal traditions, takes a felt pen and draws directly onto the skin of the model, marking out the line of points on the skin that correspond to the outline that the student has drawn on the pad. We shall call this line on the body the *lifted outline* to distinguish it from the *outline* that lives on the sketch pad.[3] Note in particular that the lifted outline is only defined by the presence of the student. It is specific to the student's viewpoint. For another student there would be a different line along the model's skin.

Pick a general point on the lifted outline and imagine a plane perpendicular to the lifted outline there. This plane makes a cross-section through the body, and near to the point in question, that cross-section would look something like a parabola, the hallmark of a fold catastrophe. That point, the skin around it, and the way that the student has seen and drawn it *is* a fold catastrophe. The model's body is not actually folded; it is the act of observation, the act of drawing, that has created the fold.

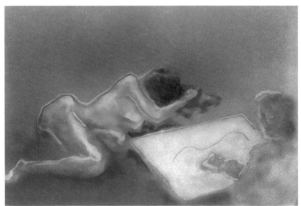

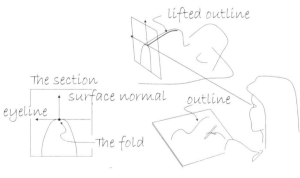

The outline is a fold.

A life drawing outline is thus nothing other than a *catastrophe map*, showing the location of the fold catastrophes. With the greatest respect, every line on Henri Gaudier-Brzeska's *Female Nude* (opposite) is a catastrophe. That is certainly a new way of looking at life drawing.

A little care is needed since the word "fold" so readily evokes the imagery of folding over a piece of paper or cloth. However, the student did not fold the model's skin. No one put a crease along the side of the model's body. The lifted outline will cross a smooth expanse of skin devoid of wrinkles and creases. The line is a "fold" only in the catastrophe theory sense, and it exists only because of the person who is looking at the model. Strictly speaking, the fold is in the eye of the beholder.

Notice that the lifted outline separates those regions of skin that the student can see from those regions that are hidden away over on the far side of the parabola of the fold. If the student were to scan her eye upward, she would see skin and then suddenly nothing. It would thus be justifiable, if a little flowery, to describe it as "the line where the visible collides with the invisible, where each annihilates the other—a line beyond which is only the void."

Alternatively we could talk of creation. Above the body, the student sees no skin, and as the eye traverses downward the eye line hits the body, and the front and back surfaces, the visible and invisible, are "born" at a fold catastrophe. Such poetic language is common in mathematics, where solutions are said to be "born" at fold catastrophes.

See how your art teacher responds if you announce, "Today I shall map out the locus of the fold catastrophes where the visible and invisible are born out of nothingness."

Although this may seem a little like empty word play, it actually touches upon something deeper. One of the driving forces behind Thom's program of mathematics was the concept of "morphogenesis," the emergence of form, and in later chapters we shall move from merely *looking* at objects to the deeper question of *how their form may have arisen*. Throughout Thom's work, and throughout this book, there is an underlying theme of creation. It is ever present in that word "genesis."

Female Nude, Kneeling and Flexing Right Arm, Henri Gaudier-Brzeska. 1914.

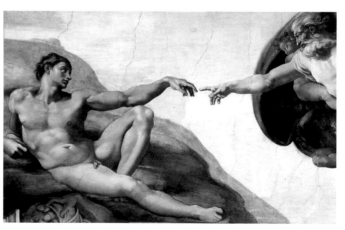

The Creation by Michelangelo, from the ceiling of the Sistine Chapel. Unbeknownst to Michelangelo, the fold catastrophes on the outline of the naked Adam, on the hand of God, and on the hills behind are all singularities, as is the emergence of form at the birth of the Universe, the greatest singularity of all.

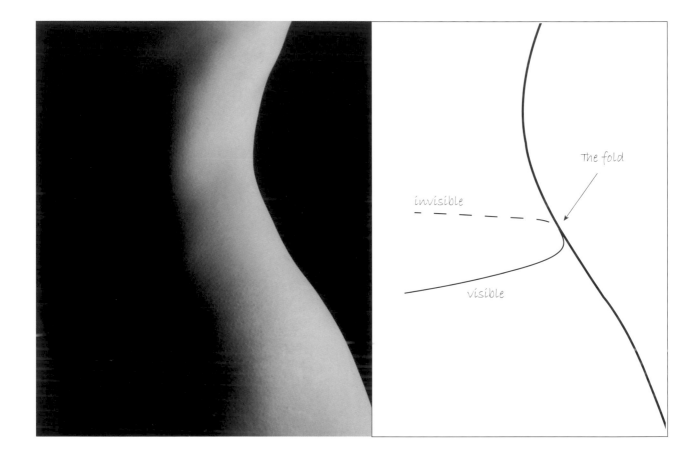

invisible

The fold

visible

Two folds back-to-back create an S-shape. The S-shape has a prominent position in art history, it being Hogarth's "serpentine line." It is also the icon of catastrophe theory, the emblematic representation of how a system can be evolving smoothly and yet can suddenly and dramatically collapse. Think of the S as a ski slope with an overhanging precipice, such that a skier traveling smoothly down the top slope suddenly drops from the lip to the nursery slopes below. This

simple idea is key to understanding how, despite everything being smooth, we can have sudden and discontinuous jumps.

Say we have written down some equations to describe the behavior of a physical system. The equations themselves may be smooth, such that the solutions to the equations are also smooth. Such smooth solutions could, however, take the form of a beautiful S-shape. When our physical system tries to follow the S, it can't—it falls from the lip of the precipice, the fold. Sometimes this might be OK—the skier might land safely and be able to carry on skiing. But sometimes the landing may not be a good one, and the system jumps from the fold to disaster, to literal catastrophe.

A simple example can be found in structural stability theory, with the "snap-through buckling" of a shallow arch. Take a train ticket or playing card and arch it gently between finger and thumb. When you press down on it you'll feel it gradually give and then suddenly pop through from convex to concave. Pushing upward reverses the process, with a steady deformation followed by a sudden pop back upward.

With a piece of card, we can pop backward and forward until we get bored, but if it were a bridge, the first such pop would be a disaster, a catastrophe.

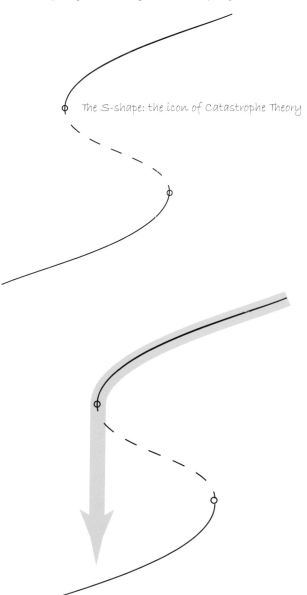

The S-shape: the icon of Catastrophe Theory

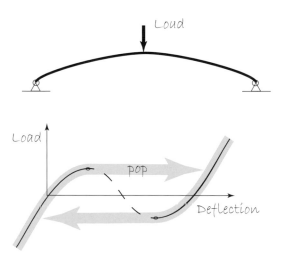

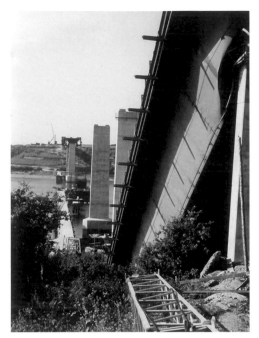

Cleddau, 1975.

The picture above shows the Cleddau Viaduct near Milford Haven in South Wales, shortly after it collapsed in 1975, killing four people. Although the viaduct is not a shallow arch design, the collapse was caused by the sudden buckling of thin plates above the supporting column. Buckling and catastrophe theory are intimately linked, but so far we have learned only the first letter of Thom's alphabet, and we would need considerably greater fluency to explain the Cleddau collapse.

We can see that the steel plates have folded, but these are not the folds of interest. The fold catastrophes associated with buckling live in an altogether different, more abstract space than the merely visual. The smooth surfaces in question here are "energy surfaces," mathematical graphs that describe the energy in the deformed structure, and the folds, if they live anywhere, live inside the heads of the bridge designers as they look at these energy surfaces in their mind's eye. Occasionally the folds may be made visible, appearing in stability diagrams on calculation pads or lecture blackboards.

Thom first expounded his theory in a work of staggering genius, the book *Structural Stability and Morphogenesis*, published in 1970. It contained a strange mixture of hard-core mathematics interspersed with musings on all sorts of this and that.

Passages such as

> Consider the easiest case, that of a static field on $B \times T$ with values in a function space $L(U, V)$. Given two other manifolds U_1, V_1, and maps $k : U_1 \to U, j : V \to V_1$ then $g_{1X} \in L(U, V)$ induces a field g_{1X} defined by $g_{1X} = j \circ g \circ k$. Of course there is no reason for the evolution operator of g_1, induced from the evolution operator of g by a diffeomorphism $h : X \to X$ of base spaces, to lead to a well-posed problem except in the obvious case in which the maps j and k are diffeomorphisms.[4]

give an indication of why the book was never going to be a best seller. Thom's use of "obvious" and "of course" may be mildly amusing to the non-mathematician, but they show that Thom is making few concessions to his readers.

Here is another passage:

When V is an open subset of U, let $G(V)$ be the set of sections of the map $V \to V$ induced by $U \to U$; there is a canonical restriction map $G(V) \to G(V)$ for $V \supset V$. We define an object c to be a maximal section of $U \to U$ for the restriction operation $G(V) \to G(V)$,...[5]

Here Thom redefines the notion of an "object" in a very austere mathematical way. I have never fully understood this definition, or its purpose, but it shows just how fundamental an approach is being taken if we have to start by redefining something as basic as an "object," something that we all think we already understand.

The book's title is somewhat ambiguous. "Structural stability" makes it sound like it has something to do with why bridges and buildings do not collapse. But Thom does not mean that at all. His phrase "structural stability" refers instead to a property of the shapes in his alphabet. His shapes are *stable* shapes. They are—in a sense we shall make precise later—*robust*. And because of this robustness, you will see them everywhere.

And because these shapes are robust and crop up in all sorts of places, it happens that they crop up in the theory of buckling, the theory of the stability of structures. In the library in my department, Thom's book is filed alongside books devoted to structural failure and building collapse. This is wrong. That isn't what he meant by structural stability. And yet, oddly, happily, the cataloguing is also absolutely right.

The other word in his title is "morphogenesis." This is unambiguous. Thom makes it clear from the start that he is interested in why things are the shape they are. In our first few chapters we shall learn his alphabet by looking at "objects." But his theory runs much deeper than that. The task he set himself was not to describe the mathematics of visual observation, of how we see curved surfaces such as bodyscapes and landscapes. Instead he was trying to explain why things turn out to have the shapes they do. He was trying to solve the riddle of biological form.

His book opens with a rubric, a quotation from D'Arcy Thompson's ground-breaking work *On Growth and Form* (1917):

The waves of the sea, the little ripples on the shore, the sweeping curve of the sandy bay between the headlands, the outline of the hills, the shape of the clouds, all these are so many riddles of form, so many problems of morphology.[6]

From D'Arcy Thompson, *On Growth and Form* (Cambridge: Cambridge University Press, 1966).

D'Arcy Thompson's book remains much loved by artists and architects. It notes that many shapes in nature crop up again and again in diverse circumstances—a jellyfish may be the same shape as a splash of liquid droplets, for example. D'Arcy Thompson does an excellent job cataloguing the compendium of natural shapes, and he puts forward mechanical hypotheses that may help explain them. For example, he postulates that asymmetries in the swimming motion of the narwhal may lead to stresses that could explain why their tusks grow to have a left-handed screw. Thom's intent is altogether different. Without making any attempt to understand the details of the physical or biological processes involved, he is nevertheless trying to provide answers to why and how the shapes emerge, but purely by thinking about "shape" in a much more abstract and much deeper mathematical way.

That Thom was unusual even for a mathematician can be seen from some of the other passages in his book. He muses whether all magic is geometry, and whether military societies "must be at least a three-dimensional manifold in order to admit a structurally stable ergodic field without singularity." He claims that art is "a virtual catastrophe," and suggests that tea leaves in teacups "may contain local accidental isomorphisms with the dynamic of human situations."[7]

Postmodernists of the 1970s loved this, even though—or perhaps because—they had little idea about what he was saying.

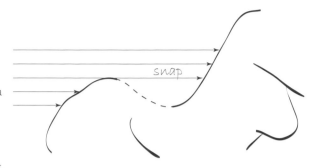

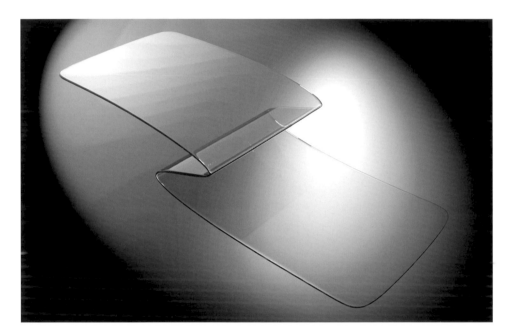

The S-shape and its associated snap-through behavior can be seen in the life class. It corresponds to looking over a depression, with the skin rising, falling, then rising again. The picture above shows an almost trivial example, looking up over the hip to the back, where what is seen suddenly "pops" as the eye line rises above the hip. If that were the only connection between catastrophe theory and life drawing it would be a rather weak link. However, there is much more, but so far we have met only the first letter in our Alphabet of Beautiful Curves: the fold is the first element in our periodic table of organic form, and the S-shape is our first molecule.

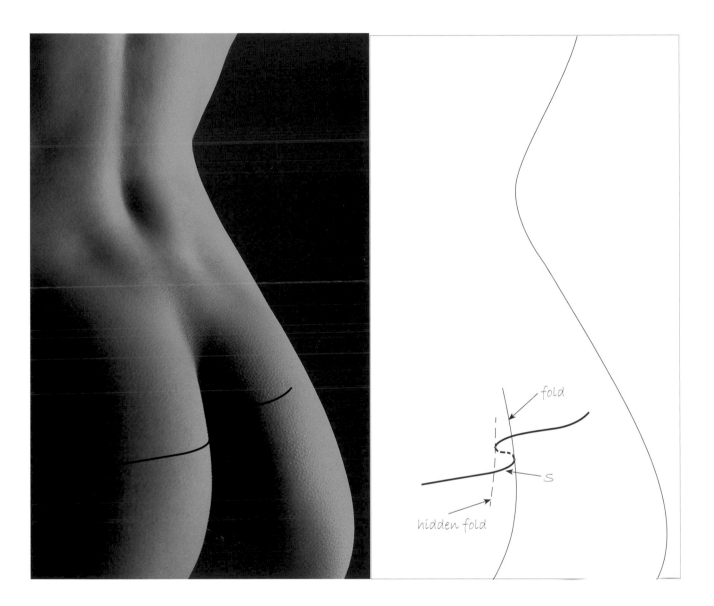

fold

S

hidden fold

The *Cusp*

The second letter in the Alphabet of Beautiful Curves is the cusp and—perhaps paradoxically—it is an infinitely sharp spike.

Cusps crop up frequently in the theory of buckling, as in the graph, lower left, showing the maximum load that can be carried by an arch at various offsets from the center.[8]

To see how such a sharp object has a central place in the description of smoothly curved surfaces, consider a ski slope like the one below. On the far side you can ski down smoothly without incident, but the near side has the precipitous overhang of the S-shape.

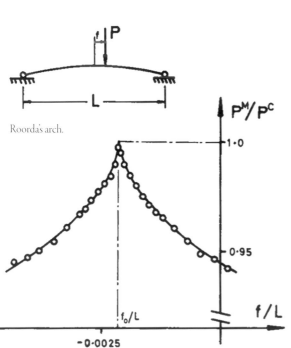

Roorda's arch.

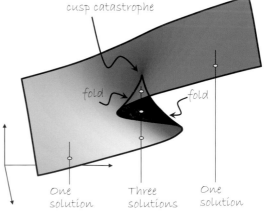

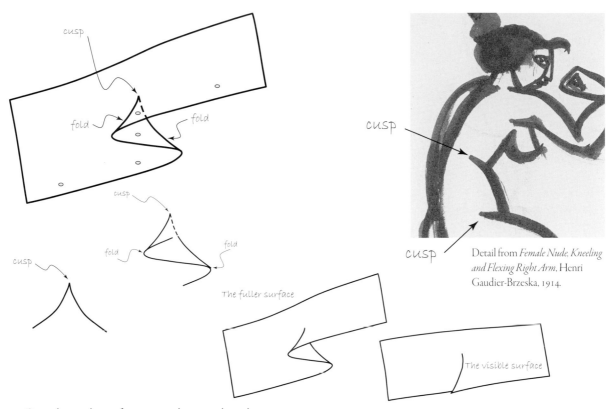

cusp

fold

fold

cusp

fold

fold

cusp

The fuller surface

cusp

cusp

Detail from *Female Nude, Kneeling and Flexing Right Arm*, Henri Gaudier-Brzeska, 1914.

The visible surface

The line-diagram shorthand

The real surface

Considering the surface as a mathematical graph, we can see that there are some regions where there is only one solution, but in the vaguely triangular region bounded by the two folds of the S, there are three solutions. That is, a vertical line there would pierce the surface at three points. These two back-to-back folds meet at a cusp, and yes, the cusp is a very sharp spike. But notice there is *absolutely nothing sharp* on the ski slope itself. The ski slope is perfectly smooth everywhere. The sharpness of the cusp is created by the act of observing the ski slope—by drawing it on the flat two-dimensional pages of this book. The sharpness of the cusp lives only on the page of the book.

In the life class, the cusp is a point on the body where an outline ends. Or, more correctly, it is the point on your retina or your sketch pad where the outline ends. Skin is opaque, and so we can't see through it to see the threeness—all we see is half the cusp, the point where an outline (fold) is curving over to collide with a hidden fold behind.

A cusp has a specific mathematical form, known as the Two-Thirds Power Law, and it can be readily explained why it must be so.

Pick any piece of smoothly bent wire and pick any general point on that wire. Then look along the wire at your chosen point.

You are now thus looking along the tangent to the wire at that point—call that direction x—and since the tangent is the straight line of best fit you have thereby removed all the linear terms from what you are seeing.

Consider now the curvature at your chosen point. One of the many planes that contains the tangent also contains the parabola of best fit. Let's call that the x-z plane. Since we have now captured the best parabola, the z direction thus contains the quadratic terms.

Perpendicular to both x and z is a direction y. Having removed the linear and quadratic terms, the only terms left in the y direction are the cubic and higher-order terms.

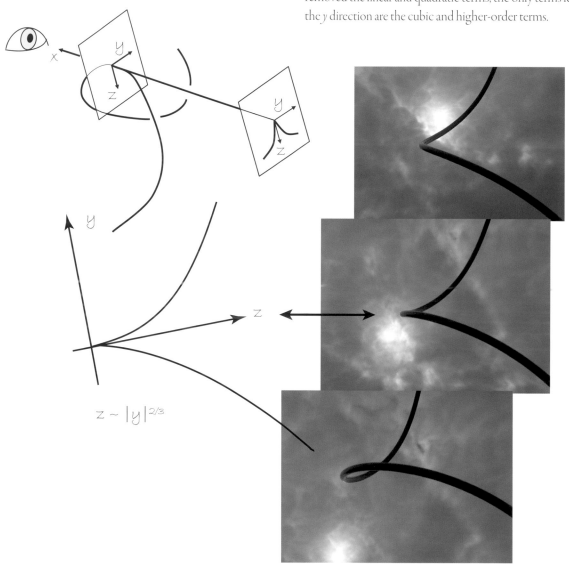

$$z \sim |y|^{2/3}$$

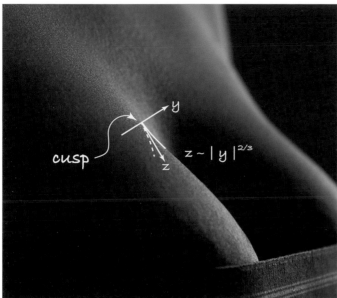

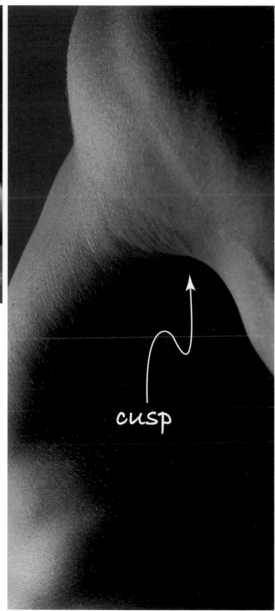

So, the leading-order terms are quadratic in the z direction and cubic in the y direction, thus $z^3 \sim y^2$, thus z goes as y to the two-thirds power. We thus conclude that when looking along any general smooth curve through space, we will see a two-thirds power law.

When we look at a smooth cusp surface such as the ski slope, the folds (the cliff edges) trace out a smooth curve through space, much like a piece of smoothly bent wire. At the cusp point we are looking directly along this wire, and so we will see the distinctive two-thirds power law.

Cusps can be found at many places on the body. An obvious example is a cleavage, when viewed obliquely. It is a little-known fact that there is a two-thirds power law at the focus of many a historical period drama, center stage in the heroine's décolletage.

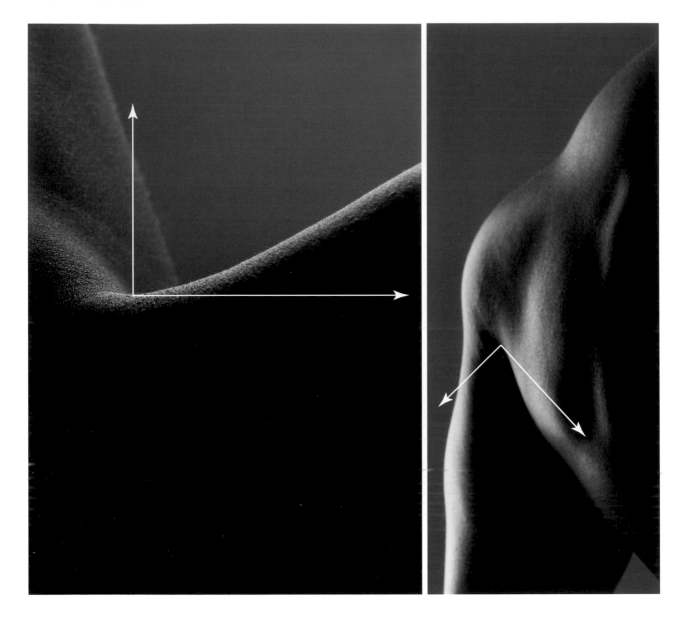

Cusps are often the central features of a stability problem. A classic example is the *Euler column*, a simple model that explains why steel columns buckle when they reach a critical load. The key objects that underlie this are two smooth but rather abstract surfaces: the *energy surface* and the *equilibrium surface*.

At any given value of the axial load, we can calculate how the total potential energy stored in the column varies as we increase the central lateral deflection. For small loads, the energy graph (plotting energy against central deflection) is usually a *U*-shape, with a single stable equilibrium at the base of the *U*. That is where the system will stay, happily and safely.

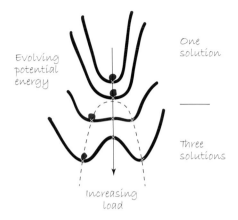

However, as the axial load is increased, the energy graph evolves to become a rounded *W*-shape. There are now three equilibria. Two of them are stable, to the left and to the right, with the third being the unstable equilibrium at the top of the central peak of the *W*.

This transition from the oneness of the *U* to the threeness of the *W* corresponds to the buckling of the column. The initial, straight, unloaded state of the column corresponds to the stable position at the bottom of the *U*. As the axial load increases, the energy graph evolves smoothly from a *U*- to a *W*-shape. The positions of lowest energy are now at the bottom of the troughs at the left or right of the *W*, and the column heads off in one of these troughs, which carries it rapidly off to large deflections. There is no actual jump here, just a rather rapid transition from small to large deflections at the point that the *U* becomes a *W*. This is the simplest form

of buckling, and it is characterized by the fork-shaped path of branching equilibria that lies along the valley floor of the energy surface.

If we extend the analysis to include imperfect columns—columns that have an initial lack of straightness when carrying no load—then the picture changes. Instead of the branching from oneness to threeness, the column just follows a nearby path, with the deformation growing at first slowly and then somewhat more rapidly. There is no sharp transition from straight to bent, just a growing degree of bentness.

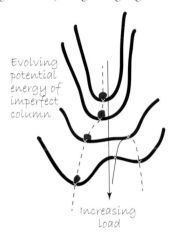

If we now gather all the forked and unforked equilibrium paths together side by side we can create the *equilibrium surface*, a smooth 2D surface in the 3D space of load, deflection, imperfection. And this surface has the form of our twice-folded wave, our ski slope.

The transition from U to W

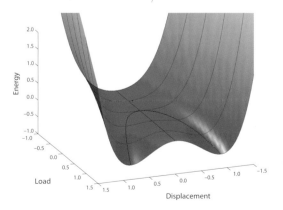

The equilibrium surface

And if we consider this only in terms of load and imperfection—which corresponds to looking at the equilibrium surface from a particular direction—we can clearly see that there is a cusp at the center of everything.

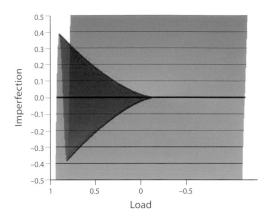

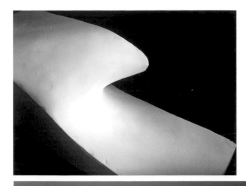

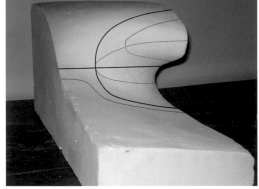

This gives a new—and deeper—perspective on Roorda's arch buckling problem that started the chapter. Although Roorda was looking at an arch rather than a column, he plotted buckling load against offset (which acts as the imperfection in this case), and he saw a two-thirds power law in the stability boundary. But now, rather than thinking that this is some highly specific property of arch buckling, we can see it instead as just a natural consequence of curved geometry. The equations for the energy of the arch are smooth, and the resulting equilibrium surface is a beautiful, smooth, curved surface that happens to have the shape of a ski slope with an overhang. Roorda's experiments effectively give a single 2D view of that surface. The line that runs along the cliff edge, colored red above, is a smooth curve, and there will be one point where the curve turns backward and downward under the overhang where we will be looking exactly along that line. Of course we shall see a two-thirds power law—we are just looking along a curved line!

A few years ago I enrolled in an evening class of sculpture at my local college. The piece I made was essentially the ski slope, in white.

"That's nice," my fellow students said, appreciatively. "What is it?"

"It is the canonical unfolding of the cusp catastrophe," I replied. "It is $z = x^3 - xy$."

"Oh", they said. "We don't really understand, but whatever it is, it is nice. Can we stroke it?" And they proceeded to run their hands over and under it, exploring its sensuous curvature.

The first three lectures of my course on stability theory, about why buildings collapse, can be given by simply getting to know that surface, by exploring its crevices and overhangs, by looking at it in different ways.

Engineers are sometimes accused of being mechanistic, happier playing with gearboxes, gadgets, and computers than facing up to the troubling complexities of humanity. They are often considered to be only capable of drawing with a ruler, with which they subjugate the lumps and bumps of the natural world to the tyranny of the rectilinear.

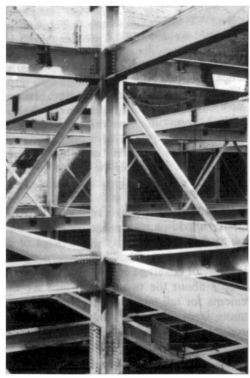

Steel beams and columns in a building frame.

The stereotype has it that engineers are largely incapable of appreciating beauty, of seeing subtlety, or of glimpsing the transcendent. This is nonsense.

The structural column that holds the building above your head may be straight, but in the wonderfully imaginative mind of the structural engineer who designed it there live the energy and equilibrium surfaces whose abstract mathematical forms are so sensuously seductive, so beautiful, that if they were made solid for you to see them, then you would want to stroke and caress them. I know this is true, for I have done the experiment.

These surfaces speak the language of curves. It is the language of my stability lectures, the language of the life class, and the language of the body, and so far we have learned only the first two letters of its alphabet.

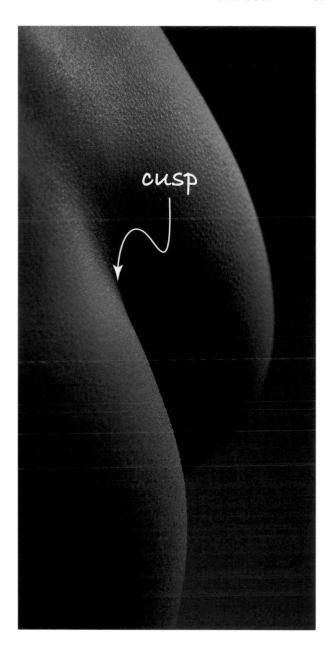

cusp

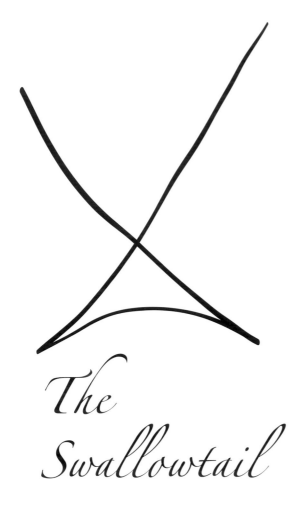

To see the full structure we can look at a translucent surface, like an irregular bubble or balloon, or even a mesh.

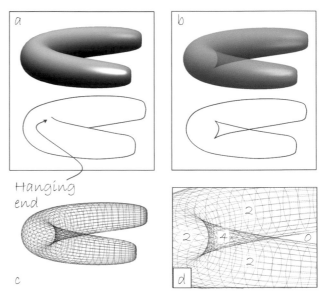

Hanging end

The Swallowtail

If the fold and cusp are our A and B, then C is the *swallowtail*. A swallowtail occurs when an ordinary, featureless outline gives birth to a pair of cusps. If the surface is opaque, like skin, then it will create an "outline that suddenly ends" that we met in the last chapter: we will only be able to see one half of one cusp, and the other cusp will be completely hidden.

Behind the hanging end of the half-visible cusp is a region of fourness: light reaching your eye through this region has had to pass through four surfaces of the balloon. The full structure of the back-to-back pair of cusps is now visible.

As we look at the balloon from various angles, we may move our heads to see the appearance of the twin-cusped region of fourness. That first appearance is the swallowtail catastrophe, and actually it is nothing much to look at. The catastrophe gets its name from the pair of cusps that emerge *after* the swallowtail. Interestingly, this catastrophe was given

an ordinary outline:
a single continuous fold

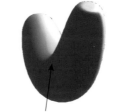

an outline that ends

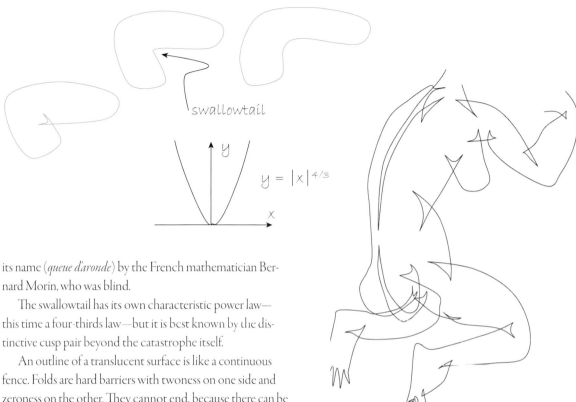

swallowtail

$$y = |x|^{4/3}$$

its name (*queue d'aronde*) by the French mathematician Bernard Morin, who was blind.

The swallowtail has its own characteristic power law—this time a four-thirds law—but it is best known by the distinctive cusp pair beyond the catastrophe itself.

An outline of a translucent surface is like a continuous fence. Folds are hard barriers with twoness on one side and zeroness on the other. They cannot end, because there can be no smooth transition, ramping up from 0 to 2, through intermediate values like 0.8 or 1.37. That would be impossible. How can we look through 1.37 surfaces? We can't, and the

If the Earth Mother were a bubble mother we should see a swallowtail nestled between the Paps of Jura.

logical consequence is that folds must run forever or form continuous closed loops.

So, if a fold can never end, and if an outline is a fold, then if we were bubble people and we went to life drawing classes we would be able to draw the full outer outline of the model without taking our pencil off the paper.

If we were bubble people there would be no need for this book, because the post-swallowtail cusp-pair would be as familiar to us as a square or a hexagon. At an early age, we would have asked our bubble mothers, "What's that funny shape under your armpit?" and our bubble mothers would have replied, "That's a swallowtail, dear."

Instead our mothers teach us of pentagons. It is a pity, for the subtle, half-visible cusp is often the hallmark of a beautiful surface.

shape with
a pattern

shape

outline

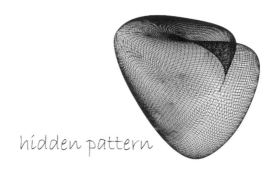

hidden pattern

The swallowtail as a hidden pattern.

Alan Hollinghurst's *The Line of Beauty* won the Man Booker Prize in 2004. It is a novel of many layers, and some are beautiful while others are decidedly bleak. Its narrative charts the evolution of a young Oxford graduate, Nick Guest, as he enters 1980s Thatcherite London, a time of excess and ego and the advent of the tragedy of AIDS.

Hollinghurst draws two of the novel's themes from William Hogarth, the British satirical painter famed for his grotesque caricatures of eighteenth-century English society. First, the novel is a "progress" after the style of Hogarth's 1730s series *A Harlot's Progress* and *The Rake's Progress*, each of which depicted the downfall of a young innocent after arrival

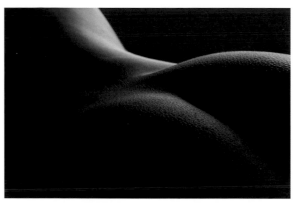

into the corrupting influences of the capital, with sex playing a substantial role in each decline. Second, the novel's title alludes to Hogarth's philosophical treatise *The Analysis of Beauty* (1753). In that short but rather arrogant volume, Hogarth identified curved lines as being sources of visual beauty. In particular, he selected a flat S-shape as the "Line of Beauty" and a similar but helically-spiraling version as the "Line of Grace." By giving the young hero Nick an interest in aesthetics—with particular expertise in the scrolling curls of the rococo—Hollinghurst interweaves the two Hogarthian threads of downfall and beauty.

Nick has a cushy job at a film production company, Ogee, owned by his lover, Wani. There is a pivotal passage in the novel in which Hollinghurst has placed Nick Guest in an ornate canopied bed. Surrounded by lush furnishings with decorative embellishments, Nick remembers the time when, in a moment of "uneasy post-coital vacancy," he had the idea of the name for the company: the "ogee" curve is Hogarth's favored S-shape.

> The double figure was Hogarth's "line of beauty," the snake-like flicker of an instinct, of two compulsions held in one unfolding movement. He ran his hand down Wani's back. He didn't think Hogarth had illustrated the best example of it, the dip and swell—he had chosen harps and branches, bones rather than flesh. Really it was time for a new Analysis of Beauty.[9]

It would seem that Hollinghurst senses there is something wrong with a theory of beauty that gives so much prominence to a piece of bent wire.

The piece of bent wire first appeared in what is arguably Hogarth's most famous work, his self-portrait, *The Painter and His Pug* of 1745. Juxtaposed with a small dog, the wire spirals above a palette in the corner of the picture, casting an S-shaped shadow across the inscription "The LINE of BEAUTY and GRACE."

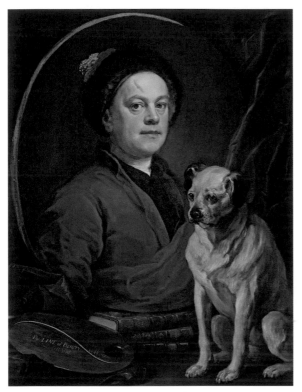

The Painter and His Pug, 1745, William Hogarth (1697–1764).

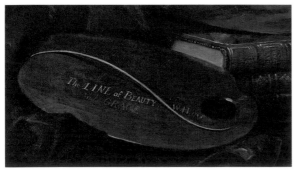

Detail from *The Painter and His Pug*, 1745, William Hogarth (1697–1764).

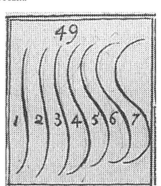

The Line of Beauty is No. 4. Detail from *The Analysis of Beauty*, plate 1, 1753, William Hogarth (1697–1764).

The Line of Grace coils around a cone. Detail from *The Analysis of Beauty*, plate 1, 1753, William Hogarth (1697–1764).

In the following decade, Hogarth evolved the concept into two forms: the flat S of the "Line of Beauty" and the helical space curve of the "Line of Grace," as described in *The Analysis*.

And beginning right from the cover page—with its quote from Milton's *Paradise Lost* and the viper's head atop the

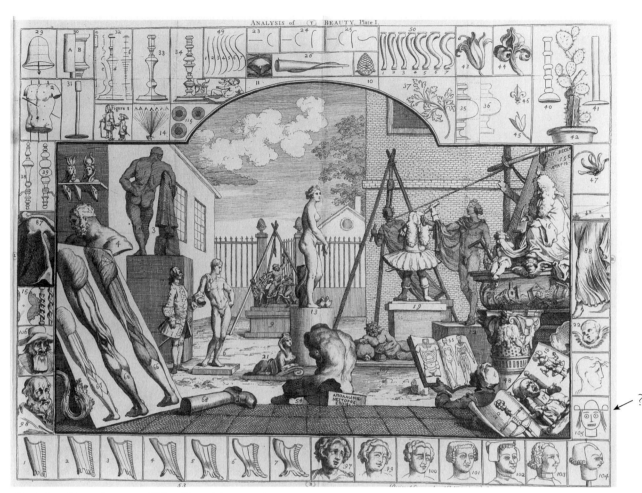

The Analysis of Beauty, plate 1, 1753, William Hogarth (1697–1764).

central S—Hogarth has associated the shape with the serpent of Eden. Yet again, we are back at the Book of Genesis.

Three years after Hogarth's *Analysis*, Edmund Burke published *A Philosophical Enquiry into the Origin of Our Ideas of the Sublime and Beautiful*, a short treatise containing a chapter with the interesting title: "Proportion not the cause of BEAUTY in VEGETABLES."

In the more general chapters, Burke established a dichotomy, drawing a distinction between two notions that he called "The Sublime" and "The Beautiful." The Sublime was large and fear inducing, an apocalyptic world of volcanoes and glaciers, with explosions, lava, and precipices. The Beautiful was smaller, more human scaled, smooth and curved. With their lightning flashes and earthquakes, the landscapes of Salvator Rosa and John Martin are Sublime, while the nymph-inhabited Arcadian landscapes of Claude Lorrain and Nicolas Poussin were softer, more delicate, and Beautiful.

A classic demarcation would be that in John Milton's epic poem *Paradise Lost*, with Adam and Eve passing through

"many a Frozen, many a Fiery Alp, Rocks, Caves, Lakes, Fens, Bogs, Dens, and shades of death" before reaching the Garden of Eden, "a happy rural seat of view" where they could wander, happy and naked, eating apples.

It is hard to ignore the synergy between the bittersweet natures of Burkean aesthetics and catastrophe theory. There is an obvious correspondence between the explosive cataclysms of the Sublime and the abrupt collapses of systems, populations, oil rigs, or bridges as they pass through fold catastrophes, as evidenced by the very word "catastrophe." But this book focuses on the less obvious resonance—the one that exists between the smoothly curved surfaces of catastrophe theory and the Burkean conception of the Beautiful.

A later school of aesthetic sensibility, the Picturesque, blurred the neat binary of Burke's decomposition. Its paintings portray crumbling ruins of former glorious halls, and nymphs and serpents abound among a great celebration of the frilliness of foliage. In a strange parallel between mathematics and art, the intricate Picturesque can be seen to emerge from the sleeker lines of the Burkean Beautiful, just as chaos theory (otherwise known as dynamical systems theory), with its infinitely ornate fractal geometry, evolved from the simpler curves and surfaces of catastrophe theory.

In terms of cultural history it is loosely correct to say that catastrophe theory was popular in the 1970s but was soon supplanted in the public imagination of the 1980s by chaos theory and fractal geometry. The mathematical chronology is slightly more subtle.

Loosely speaking, chaos theory is the study of dynamical singularities, the addition of the time dimension leading to a richer set of singularities than catastrophe theory, such as the Andronov-Hopf and the Bogdanov-Takens bifurcations, and fractal exotica such as Smale horseshoes, Feigenbaum cascades, homoclinic tangles, and chaotic attractors.

Fractal geometry grew from pure beginnings in the late nineteenth and early twentieth centuries, with Cantor, Julia, and Fatou sets, and with the concept of non-integer dimensions developed by Hausdorff. It received a huge boost in the late 1970s and early 1980s with the work of Benoit Mandelbrot, who, aided by contemporary developments in computer graphics, consolidated and built on the earlier ideas with books such as *The Fractal Geometry of Nature* and with his studies of the fractal set that now bears his name. Beyond the austere theorems, Mandelbrot's wider program shared similarities with Thom's intentions. Mandelbrot had a geometry that described natural forms—the shape of a cloud, a tree fern, a coastline, a river system—for which the squares and pentagons of Euclid and Archimedes fall woefully short. Thanks to computer graphics, the world now largely knows about fractals. Thom's catastrophes, though, remain less appreciated in the world of art, but they have their place in the scheme of things, not with the filigree ferns and foliage or the wispy/billowing clouds of the Picturesque but with the smoother rolling landscapes and nudes of Burkean Beauty.

On the subject of the Beautiful, Burke identified *irregular variation* as an attractive property of a curve. Fractals apart, most other attempts to apply mathematical concepts to art theory have focused on pristine forms, tessellations, symmetries, and proportions, but Burke's emphasis on smoothness—and particularly on irregularity—puts his aesthetics firmly into the realm of catastrophe theory. Catastrophe theory derives its power from exactly those two properties. Thom's curved surfaces are not spheres, cylinders, or cones: they are smooth and curved but they are also irregular.

Consider for a moment whether Hogarth's contention that there is a single Line of Beauty is as plausible as Burke's proposal that there are infinitely many such lines, each smooth, curved, and irregular.

Some of those lines will be the curves traced on your retina when, like Nick Guest, you contemplate the curved surface of your lover's back. And those curves speak Thom's language.

Central to many a painting is a beautiful swallowtail, nestling on the waist.

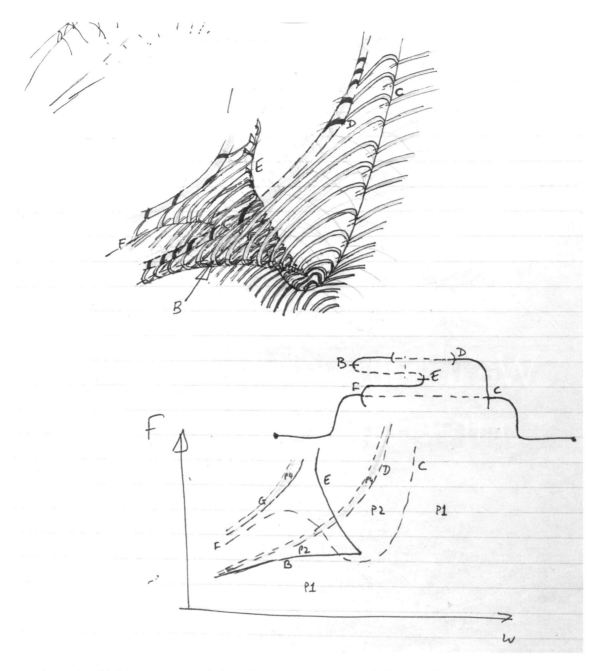

One of my sketches of the bifurcation structure of a chaotic dynamical system made it onto the front cover of a magazine. The equations concern the stability of a ship being hit broadside by waves, and the diagram shows that catastrophes can be found in dynamical systems. Here the fold lines E and B meet at a cusp, which almost touches the surrounding fold C in the manner of a hyperbolic umbilic catastrophe. Catastrophe theory and chaos theory share much common ground.

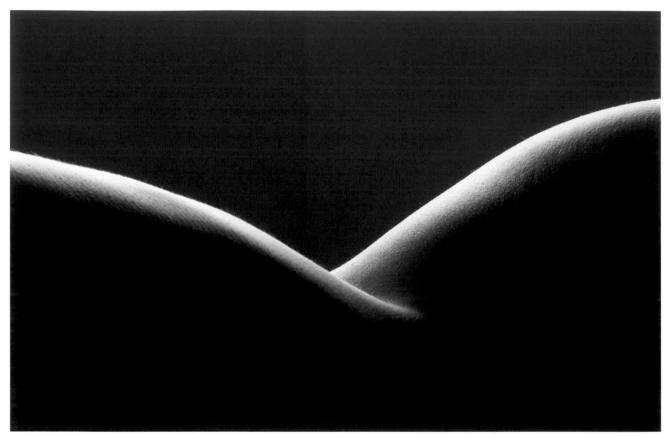

A swallowtail—one distillation of the essence of beauty.

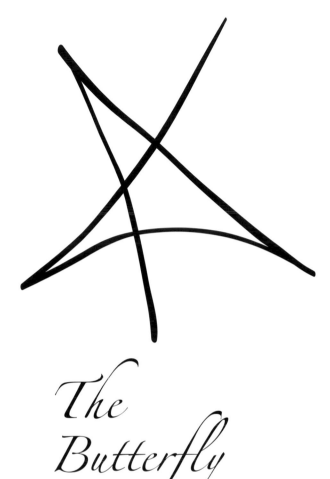

The Butterfly

tail drawing. As was the case for the swallowtail, this is not actually the diagram at the catastrophe itself but a little beyond it, the *unfolding* of the butterfly.

The difference between the two catastrophes becomes more evident when we add lines to indicate the accompanying surfaces for which the spiky line diagrams are merely a convenient shorthand.

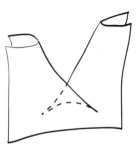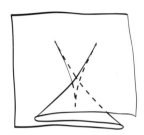

Notice that the butterfly has no external outline. There is no sky visible behind it, as there is between the gap in the two hills of the swallowtail. That means butterflies will not be seen on the edge of the body but on internal outlines.

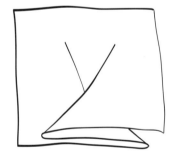

In its stripped-down line diagram form, the butterfly diagram is strikingly reminiscent of the cartoonist's y-shape shorthand for the female pubis, but the third cusp, hidden behind, would be anatomically incorrect.

The fourth cuspoid is the *butterfly*, and it is quite rare. The catastrophes become increasingly less common as one proceeds up the sequence. Folds can be seen very readily, cusps less often, and so forth. I once spent the best part of a pleasant evening trying to find a butterfly on my wife's hip, and without success. I did find something else though, quite unexpectedly, of which more later.

It can be readily seen that the butterfly diagram, above, has been created by adding a single extra line to the swallow-

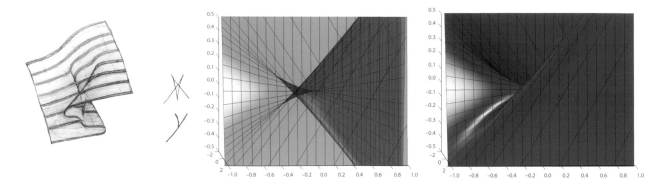

Although elusive, butterflies can be glimpsed on the human body, the heart-shaped shadow in the armpit of the Bill Brandt photograph being an indication of a nearby butterfly.

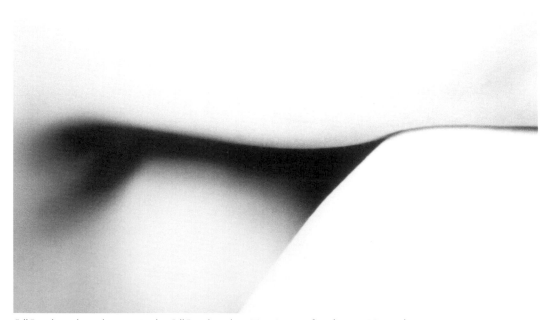

Bill Brandt, *Nude, London*, 1954, April. © Bill Brandt Archive/The Museum of Modern Art, New York.

The butterfly catastrophe is hidden behind some everyday physical phenomena. Each year, the undergraduates in my department spend a week in Norfolk getting hands-on experience at construction, building small-scale versions of real projects. One such task is the Ravenspurn Oil Rig project, which involves the students casting a large, hollow, concrete cuboid with a steel platform atop, and then floating the whole edifice across a lake before deploying it into its final resting place with its base on the lake bed. In the week before they go I ask them:

"Have you checked it will float?"

"Of course we have," they reply.

"Good," I say, "and have you checked which way up it will float?"

"Hmmm," comes the reply.

Of course they haven't—that is a substantially harder problem. And so we spend a happy week studying hydrostatic stability. It is a good left-brain, right-brain exercise. It requires detailed mathematical calculations of stability loci, but having done this, the students realize that the mathematical answers they are obtaining—which involve much catastrophe theory—are actually rather beautiful. I mark the project with complex numbers, giving real marks for realism—their calculations must be correct—and imaginary marks for imagination, giving them the opportunity to submit their answers in any artistic medium of their choosing.

The English mathematician Christopher Zeeman was one of the few who, in the 1970s, took up Thom's program

with some enthusiasm, finding potential applications for catastrophe theory in many areas of the biological and physical sciences, engineering, and even the social sciences. Some of the latter applications—finding cusps in the dynamics of prison riots, for example—were rather speculative and seemed to achieve little other than the alienation of a good many skeptical scientists. But one of the undeniably rich and powerful applications was Zeeman's reframing of the ship stability problem in terms of catastrophe theory. The stability of ships is an age-old problem, dating back into the mists of nautical history, and one would think that by the twentieth century the theory would have been fairly done and dusted. However, Zeeman was able to shed new light in old places. The diagram below, taken from a paper by Zeeman, shows that a flat-bottomed boat carries a butterfly catastrophe on its stability locus. Provided that the center of gravity of the vessel is below this feature, the ship is stable.

The problem that my students face is that, having located the butterfly on the stability boundary, their method of deployment—of slowly filling the hollow flotation tank with water—means that the butterfly and the center of gravity are drawn inexorably closer, such that—at the point of final deployment—the oil rig will inevitably lose stability. There is little they can do about it, given the short time available. (There is a nice clip on YouTube of them deploying their rig.) They know what is going to happen. At a certain point the center of gravity will cross one of the first folds in the butterfly, and the rig will heel over—not completely, but to an angle of about 17 degrees, where it will sit quite stably. As more water is allowed in, the heeling will get worse until finally the rig will turn turtle. Their ad hoc stabilization method, of pulling on guy ropes, hoping to prevent disaster, is doomed. They squeal as the rig tilts, knowing that there is a 20-tonne butterfly on the other end of the rope, easily capable of winning this particular tug-of-war. They are only saved by the shallowness of the lake. A toe of the base digs in, and then the rig settles safely. In a real sea, with a full-scale rig, they would have watched helplessly as billions of pounds' worth of structure disappeared forever below the waves.

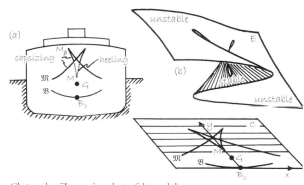

Christopher Zeeman's analysis of ship stability.

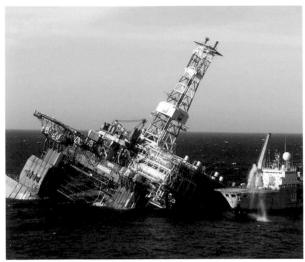

Heeling at full and model scale.

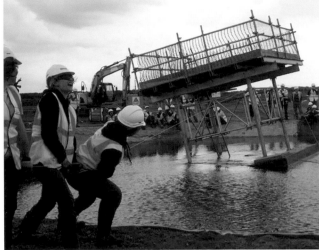

Photo by Alasdair Parkes.

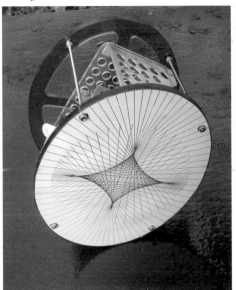

Michael Thompson's catastrophe machine (left), and two student artworks explaining their mathematics. One draws on 1970s craft traditions while the other recognizes the ready-mades of Marcel Duchamps.

The
Wigwam

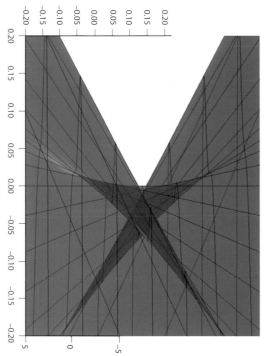

The next cuspoid in the sequence is the wigwam. Again the diagram for its unfolding is obtained by adding a line to its predecessor, such that there are now four cusps.

Wigwams are exceedingly rare, and in a technical sense you are unlikely to ever see one.[10] However, given that we tend to focus on the unfolded version just beyond the catastrophe, and given that the wigwam does have a "gap in the mountains," its hippie-esque pentangle morphology can be found near external outlines of the body, thereby actually making it easier to spot than the butterfly.

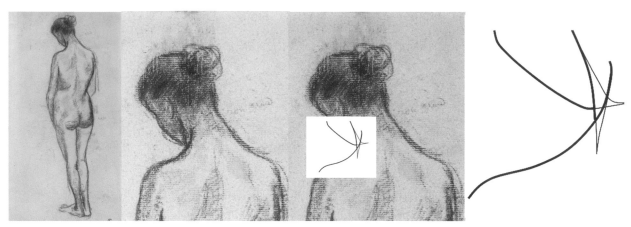

Camille Pissarro, Full-length standing nude woman, viewed from behind.

The girl's neck in the sketch above, by Pissarro, exhibits a near-wigwam morphology.

Wigwams involve four cusps, and we have seen how two adjacent swallowtails—with two cusps each—can readily be found on a ridge-line fold. With a change of viewpoint, looking more closely along the ridge-line, the two swallowtails can be brought closer together such that the four cusps approach the post-wigwam morphology.

However, it will not in general be possible to change your viewpoint in such a way that all four cusps collide at a single point, the actual wigwam catastrophe. And even if you took the trouble to arrange your eye and the model to achieve this, it would not be worth the effort because—like the swallowtail and butterfly—the exact point of catastrophe is visually unremarkable—it is the cusped unfolding beyond the catastrophe that is more distinctive.

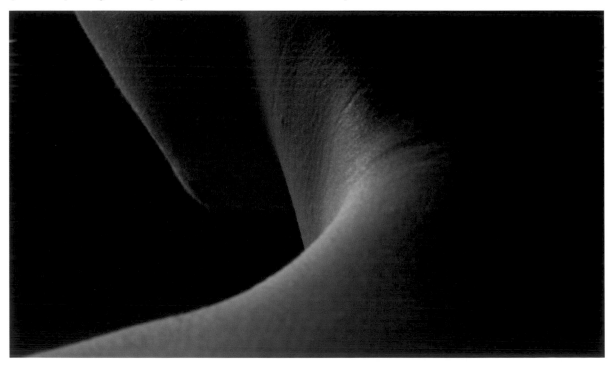

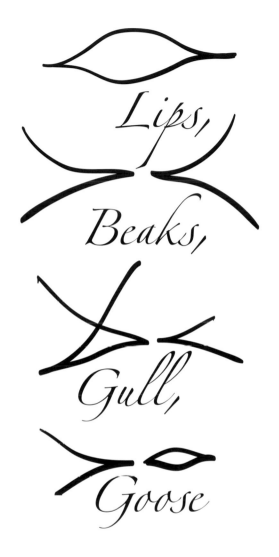

Lips,

Beaks,

Gull,

Goose

cause although the line diagrams may evoke the words, the corresponding surfaces look nothing like what their names might suggest.

In a lips transition, first there is nothingness and then two cusps emerge back-to-back, their sharp ends pointing away

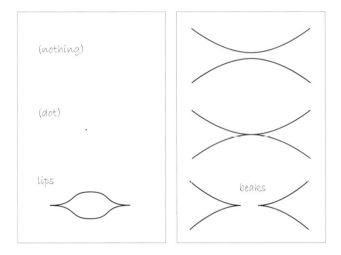

from each other, and their folds connecting at top and bottom. In a beaks transition, two approximately parallel folds touch, and two beak-to-beak cusps emerge with a gap between them.

The lips transition can be seen as one moves up to look over an isolated smooth hill on a flatter curving plain. In a bodyscape such a transition may be observed on the nipple or ankle.

Rather like the famous Necker cube, the mesh-only projections of the transitions (shown below each figure overleaf) correspond to more than one surface. A mesh with a pimple, when seen from the opposite viewpoint, is a mesh with a dimple.

Lips transitions can be seen at dimples on the chin, cheeks, and the small of the back. And there are the small

As well as the catastrophes, there are *transitions*. These are just like catastrophes, but for various mathematical reasons they are considered less fundamental and thus have not been deemed worthy of bearing that name. Each involves the collision of a number of cusps.

The lips and beaks transitions—like the swallowtail—each involve two cusps. Their names can be misleading, be-

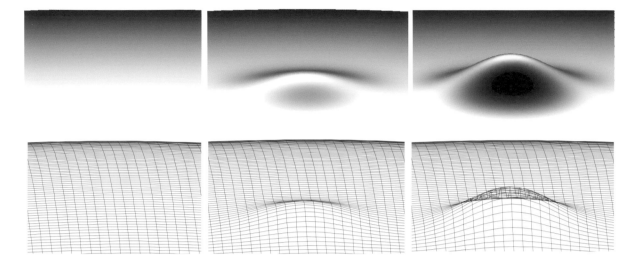

hollows that can nestle just above the collarbone, and the suprasternal notch at the base of the neck of Katharine Clifton (Kristin Scott Thomas), which so fascinated Count Laszlo de Almásy (Ralph Fiennes) in *The English Patient*.

From oblique angles the navel can create similar patterns, although the internal anatomical detail visible from frontal viewpoints prevents the occurrence of a true lips transition.

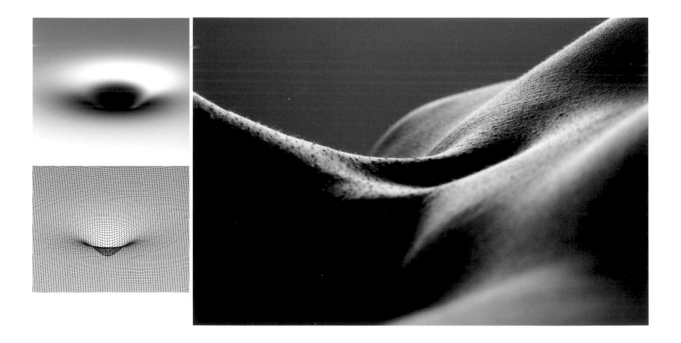

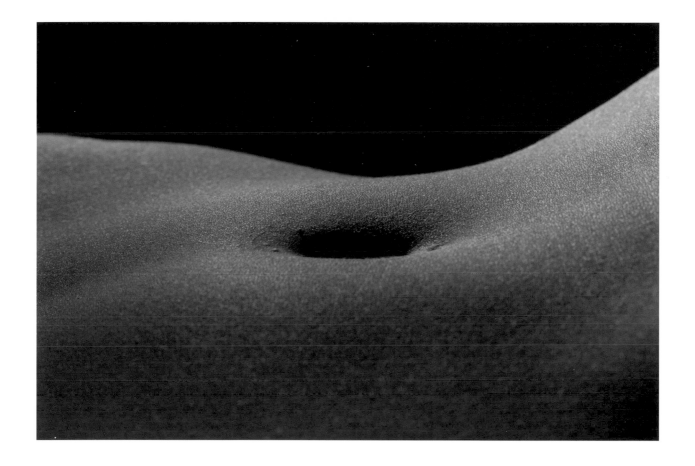

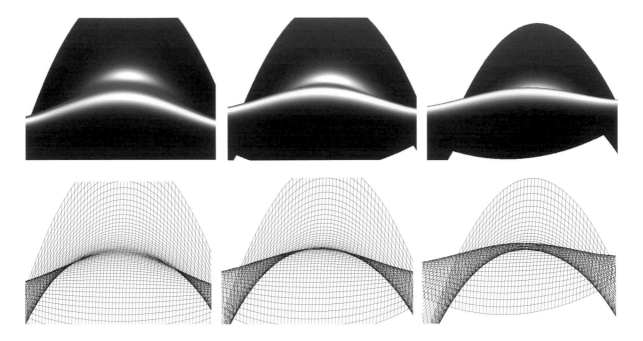

The beaks transition can be seen where the transverse curvature changes along the length of a ridge, such as looking along a shoulder toward the neck or looking along an arched back from either end.

Seen from above the lower back, there are strong cusps to left and right above the hips. As one lowers ones viewpoint, these cusps rise to meet beak-to-beak across the center, as the mound of the pelvis rises above the small of the back. This is very much the landscape that Nick Guest was contemplating on his lover, Wani.

A beaks transition can also be found at the side of the breast, where a cusp below the breast rises to meet a cusp below the arm.

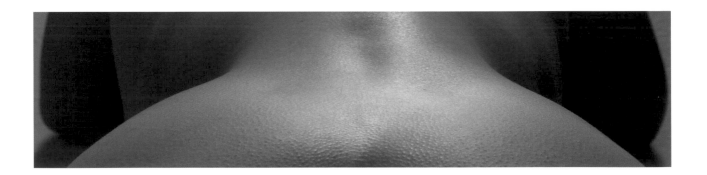

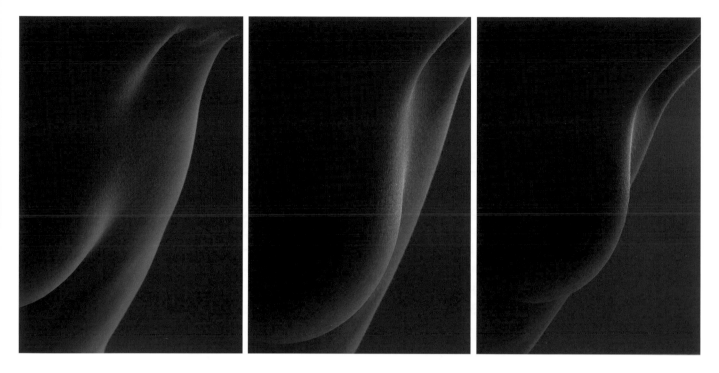

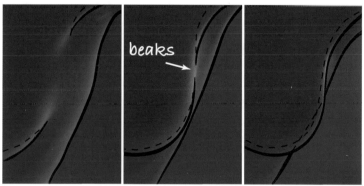

But any artist could object that, no, actually that is just mindless photorealism. The "art" in a drawing is introduced somewhere along the projection step, as the image on the retina is transferred through the artist's brain and her hand responds by making marks on paper. This is true, but—and here's the rub—no matter how much the artist distorts the photorealism into the artistic rendering, provided she does this *smoothly*, then cusps will still be cusps. Cusps persist.

There will be a two-thirds power law cusp at the top of the leg in the photorealistic image, and a two-thirds power law cusp in the distorted image. This is what Thom means by *structural stability*. Cusps on outlines are structurally stable shapes. They do not disappear if you move your head a little. They are still there, obeying Thom's two-thirds power law, even if you distort the image massively (but smoothly).

The only way to get rid of a cusp on an outline is to apply a non-smooth distortion. So, for example, catastrophe

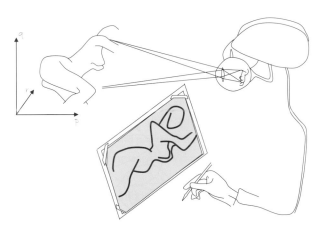

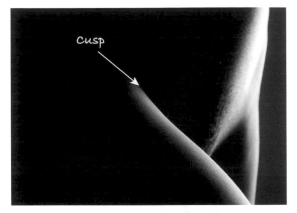

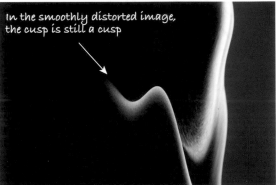

theory does not apply in cubism, because the smooth skin gets creased into sharp, angular corners. It does apply, though, in the bendy, stretchy world of Salvador Dalí and in the Dalíesque photographs of André Kertész that predate Dalí.

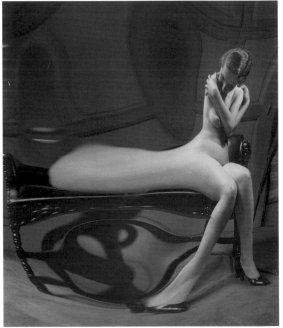

Distortion # 78, Paris, 1933. © Estate of André Kertész/Higher Pictures.

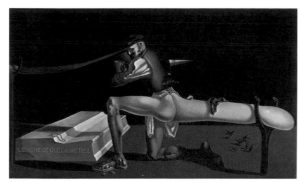

The Enigma of William Tell, c. 1933 © Salvador Dalí, Fundació Gala-
Salvador Dalí, ARS.

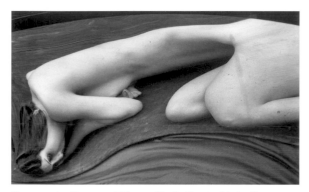

Distortion # 126, Paris, 1933 © Estate of André Kertész/Higher Pictures.

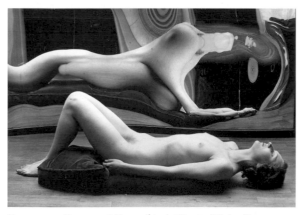

Distortion # 45, Paris, 1933 © Estate of André Kertész/Higher Pictures.

Note, though, that cusps on bits of bent wire are *not* structurally stable. The three photos in chapter 3 (on page 16) show that a cusp on a bent wire is ephemeral, fragile. Move your head a little and it breaks up into either a smooth arch or a loop. This is one reason why Hogarth's identification of a bent wire as the Line of Beauty is flawed. Outlines of bodies do not speak with the rhythm of arch, cusp, loop. Loops can be interesting, but they do not speak to us of body forms.

We now have all the features that you will see, generically, in a life class. These are the *visual events*. You will definitely see folds, because the model has an outline. It is highly likely that you will also see cusps, because cusps can be seen from large, open regions of viewpoints. In the life class you are looking at a 2D-in-3D manifold, and in that case, folds and cusps are structurally stable.

Swallowtails, lips, and beaks will only be visible if your eye happens to lie on certain infinitesimally thin sheets that permeate the room. These sheets divide the space into regions of who sees what from where.

The butterflies, gulls, and geese are rarer yet and will only be encountered if you look from a few very specific directions. In one sense you may feel they are so rare, so hard to find, that they cannot be important. In another sense you could consider them to play a central role, acting as the organizing centers around which the whole topology of visual observation drapes itself.

That is it. That is the complete classification of the generic visual events, the four cuspoids and the four transitions. There are rarer visual events, like the wigwam, and you will notice that we have not yet mentioned the umbilics. These cannot be seen in a life class for the simple reason that they require the surface—in this case the skin—to be able to pass through itself. We save those as a treat for later.

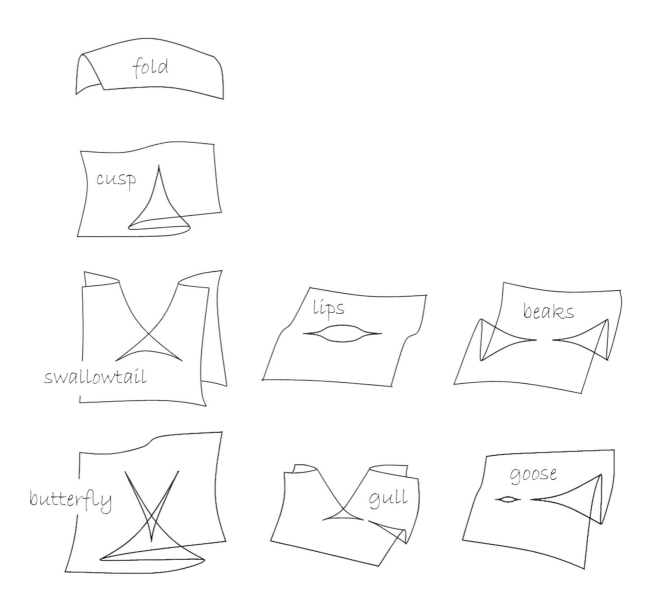

The Visual Events.

Moiré and Dupin

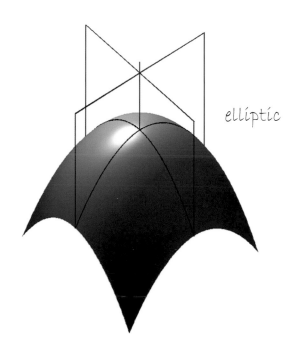

elliptic

Einstein taught us that if we want to understand the Universe we need to understand curvature, and it is obvious that this is also true for a book about curved shape. But because books are flat, we shall need to keep things simple, so we shall stay with 2D-in-3D surfaces, even though the program applies to four-dimensional space-time continua and the like.

There are, generically, two types of 2D-in-3D smoothly curved surfaces. They can be either *elliptic* or *hyperbolic*. An elliptic surface has a bowl or a hilltop shape, with everything curving in one direction, whereas a hyperbolic surface is saddle-shaped, with curvatures in opposing directions.

The nature of the surface is critical for the visual events because you will only ever see cusps—and the higher-order catastrophes and transitions—on hyperbolic regions. The only catastrophe an elliptic region can generate is a boring old fold.

Moiré interferometry provides a neat way of determining whether a surface is elliptic or hyperbolic. By putting dark stripes, perhaps a millimeter wide, across a flat, coin-sized piece of transparent material (leaving transparent gaps of equal width), one can create a curvature detector. When illuminated with a bright point source, the shadows of the

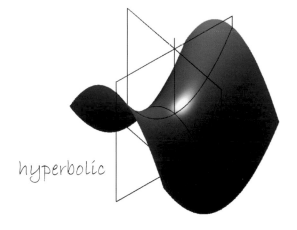

hyperbolic

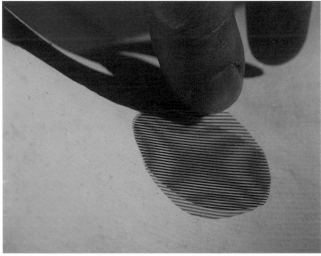

stripes undergo Moiré interference with the stripes themselves. This Moiré interference is just an optical effect that creates thicker bands of dark and light. It is the same phenomenon as can be seen on Moiré fabric that was popular for making dresses and sashes in the Middle Ages, where the overlaying of different weaves leads to shimmering, larger-scale patterns of stripes that swirl as the wearer moves.

When the disk is placed on elliptic regions, a set of concentric ellipses appears, and when placed on a hyperbolic re-

gion, a set of hyperbolae appears, nestled around a central cross. It is almost as if the surfaces are shouting out, "Look at the ellipses! I am elliptic!" and "Look at the hyperbolae! I am hyperbolic!"

These patterns of ellipses and hyperbolae are the *local* contour maps—not contours of absolute vertical height but contours relative to the plane of the coin-sized disk of transparent material. On a standard contour map of the landscape, ellipses gather around hilltops, but with the curvature detector, any part of an elliptic region has its chance to have its day in the sun, to be the local hilltop. The curvature detector can thus reveal a great deal of information about any point on the surface.

The effect can be readily scaled up. A document consisting of a set of black stripes can be easily created on any word processor and then printed onto overhead projector film, creating an A4-size curvature detector. Here are a few of the pictures I took when I placed such a film on my wife's back.

Actually two are of my wife's back and two are of pitch pine floorboards, the similarity between the Moiré patterns and the patterns of wood grain being irresistible. It is almost as if the grain is the last vestigial cry of the timber, a plaintive echo of its organic form before it was sawn to conform to the rigid rectilinearity of the man-made world.

The Moiré effect can be scaled up further yet to obtain whole-body information. It requires a Perspex screen about the size of a door, with the black stripes about two millimeters thick with an equivalent thickness of clear spacing between each stripe. When lit from the front, the effect when a life model walks behind the screen is dramatic, the whole body being covered with dancing zebra stripes.

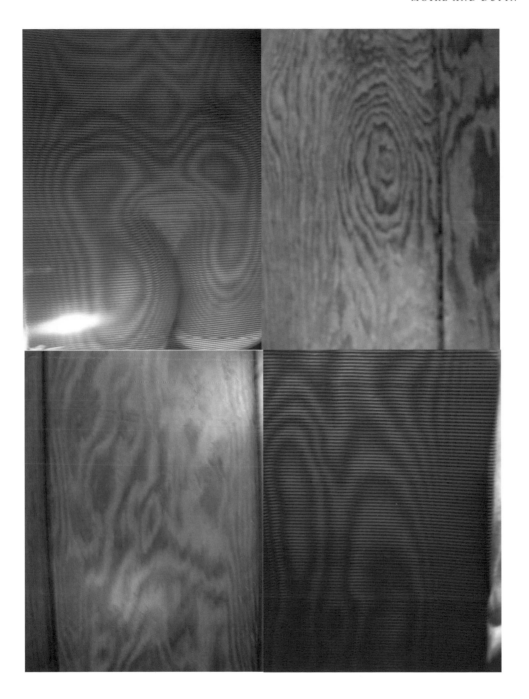

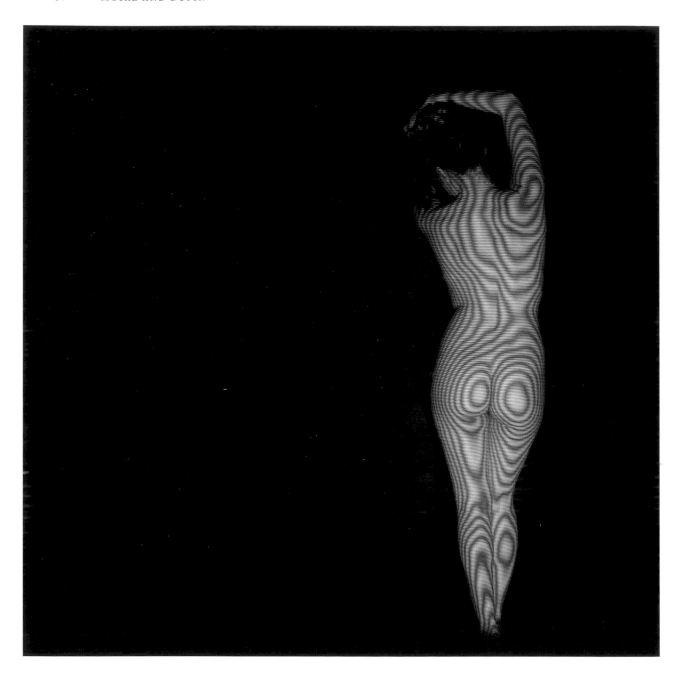

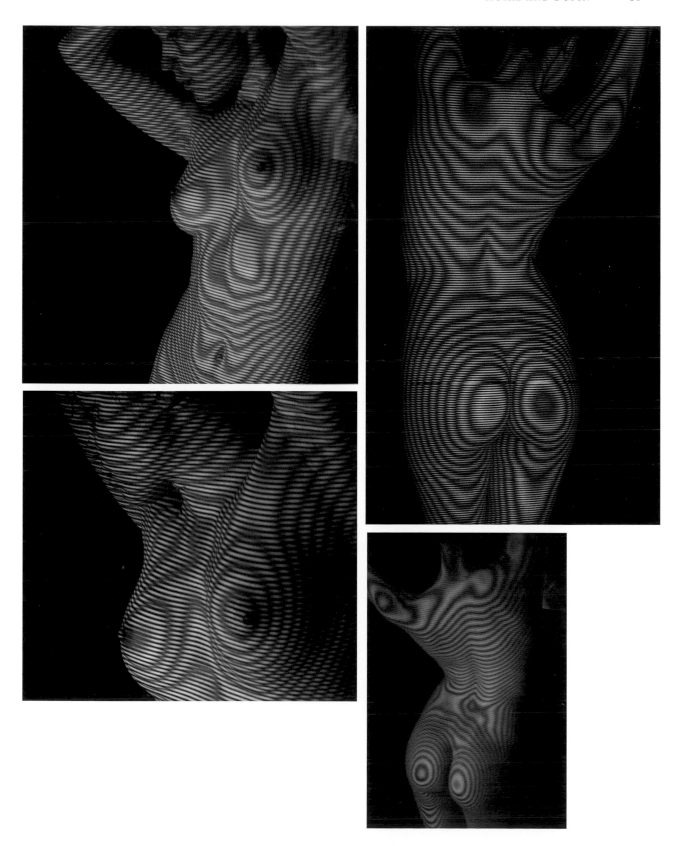

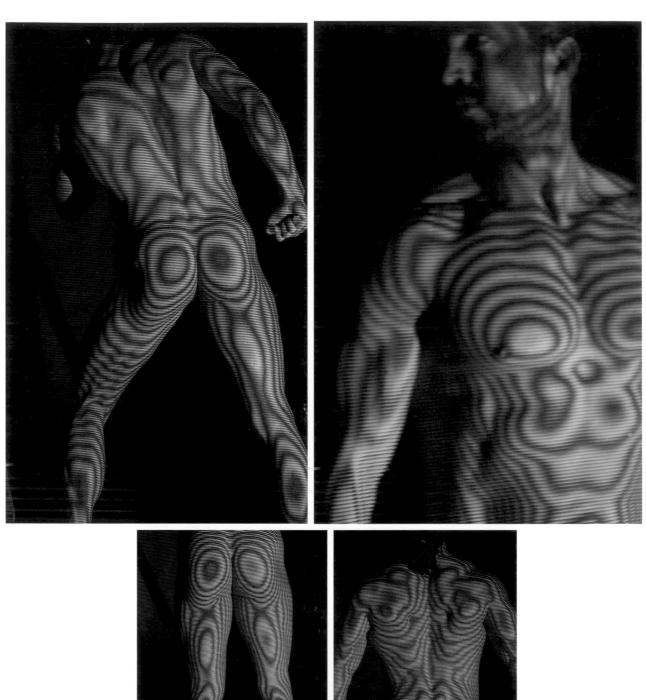

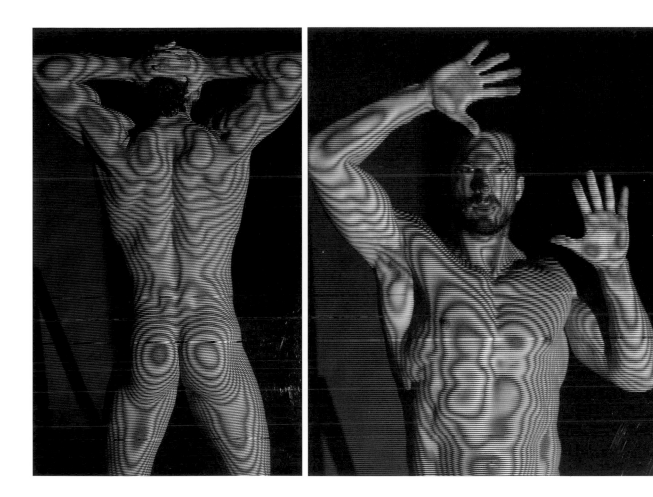

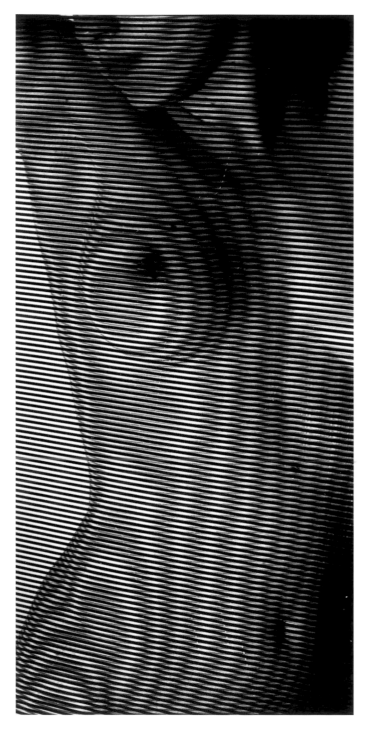

To a first approximation, the results reveal what was already known. Breasts, pectorals, and buttocks are elliptic, and the waist region is hyperbolic, although the double cross in the small of the back shows that the morphology is actually somewhat more subtle in its detail. Hyperbolic regions can also be seen under the arm, under the breasts, and behind the knees.

This demarcation of the surface into its two generic forms is the first step in determining the organization of the visual catastrophes. Cusps and higher-order events can only be seen on hyperbolic regions. Now, not only do the cross-shaped Moiré patterns tell us that the region is hyperbolic—and thus there is the possibility of seeing a cusp there—the legs of the cross tell us which directions to look from in order to see a cusp.

The cross shape is the *indicatrix of Dupin*. At any point on a hyperbolic surface there are opposing saddle-like curvatures. The curvature has its largest magnitudes—one positive, one negative—in two orthogonal directions, known as the Principal Directions. These correspond, on a saddle, to the upward-curving ridge-line running along the horse's spine and the downward-curving transverse direction that the rider's legs will follow. The indicatrix cross lies at an angle to the Principal Directions. The indicatrix corresponds to those directions in which, to first order, the saddle is flat. Not flat with respect to gravity but locally flat in the sense that you could place a straight-edged ruler along the surface in those directions.

The indicatrices are colored red and blue opposite, and the Principal Curvatures are green.

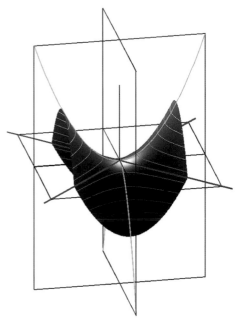

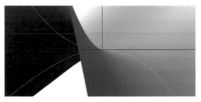

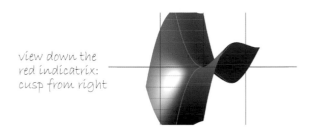

*view down the
blue indicatrix:
cusp from left*

*view down the
red indicatrix:
cusp from right*

The diagram above is of a pure quadratic saddle, so the in-dicatrices actually live on the surface for their full lengths. For a generic saddle there are cubic and higher-order terms, and so one half of each indicatrix points out of the body, and one heads inside the body. At any point on the hyperbolic re-gion of an opaque body a cusp can thus be seen there by looking in one of two directions, the outward-pointing red and blue indicatrices. One will have a cusp coming in from the left, and one will have a cusp coming in from the right.

Of course, if the skin were transparent then cusps could be seen by looking along the other half of each indicatrix, but then they would be cusps on the hidden surfaces behind the front surface.

Imagine now that there are laser beams shining out along all legs of the indicatrices, putting two diametrically opposite red and two diametrically opposite blue dots onto the celes-tial sphere, a giant spherical shell that surrounds the body. And imagine this happens at every point on every hyperbolic region of the whole body. What you have created is the *asymptotic spherical image.* The celestial sphere will have large

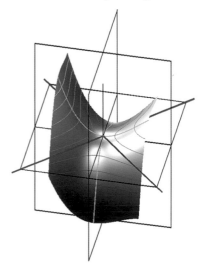

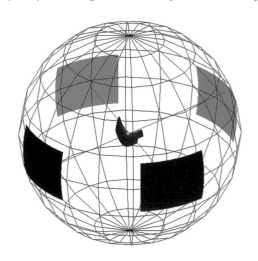

purple splotches on it because every red splotch will overlap with a blue splotch. This follows a sort of conservation of cusps law: cusps are created in pairs at swallowtails, lips, and beaks, each of those creating a pair with opposite-pointing cusps. Looking back at the body from within a purple patch on the celestial sphere you will see two shining points of light at different points on the body, one red, one blue, each on the very nose of a cusp (although of course one should never look down laser beams).

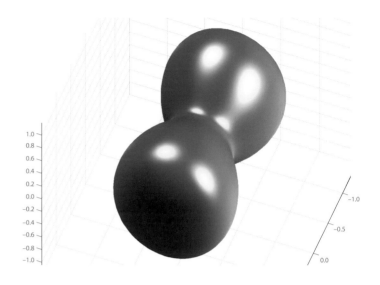

We have seen how the catastrophe shapes on the body outline are, in some sense, "hidden patterns," such that we could only see their full morphologies if we had bubble bodies. But there are catastrophe patterns that are even more deeply hidden. The space around the model's body is permeated with invisible sheets that demarcate who can see what from where. And these sheets can fold and interact with each other. The model's body thus creates patterns of catastrophic shapes—folds, cusps, swallowtails, and the like—out on the celestial sphere.

The edge of every purple blob out on the celestial sphere is a fold, and looking back at the body from here, you will see a blue cusp collide with a red cusp at a swallowtail, a lips, or a beaks. And the edges of the purple patches can themselves have cusps on, these being the directions from which to look to see a butterfly, a gull, or a goose.

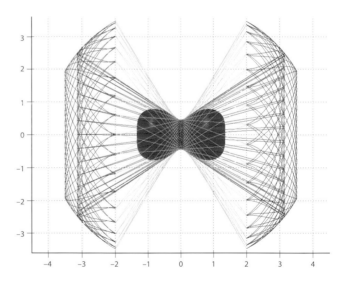

This is getting rather complicated, so let's keep things simple. Consider a smooth hourglass surface lying horizontal. It has a hyperbolic waist nestled between elliptic bulb ends. The indicatrices at each point on the waist region can be projected out to the celestial sphere, and this shows that cusps on the waist can only be seen if the waist is viewed obliquely, from within one of the hoop-like regions to the left and right.

Researchers[12] at my department have developed a technology for 3D image capture and interpretation that they use for medical applications, such as measuring chest movements to allow non-intrusive assessment of

lung capacity. Wishing to illustrate here how a real body cre-
ates sheets of catastrophe that extend out to the celestial
sphere, I persuaded them to apply their techniques to a life
model.

The model's waist region was optically scanned to gener-
ate a 3D point cloud of surface coordinates. I could then nu-
merically smooth and differentiate these (twice) to deter-
mine the local curvatures. I then identified the hyperbolic
regions and computed the indicatrix directions at a grid of
points thereon. Extrapolating the indicatrix vectors out to
infinity shows that the general features deduced for the hour-
glass carry across to the real body. The directions from which
cusps can be seen lie in thick cones that form hoop-like re-
gions above and below the waist.

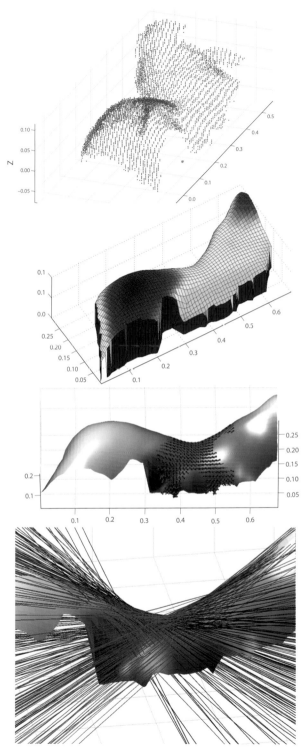

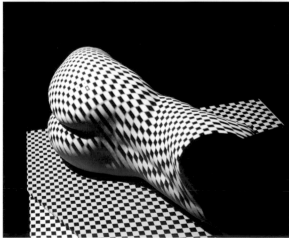

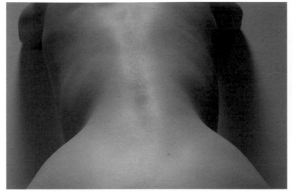

Dramatic cusps on the waist seen from below.

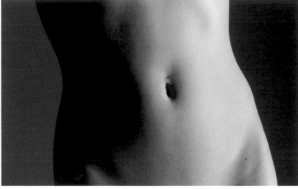

Full frontal, the waist has plain cusp-free folds.

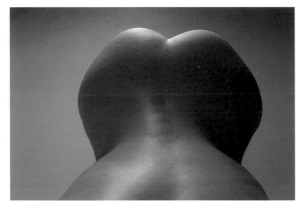

Seen from above, dramatic cusps reappear.

It follows that the classical perspective on the naked human form, the "full frontal," is unlikely to reveal any cusps on the waist. These are revealed only by looking from angles above or below the waist.

If the model in a life class stands up straight, then waist outlines will be largely featureless. However, if the model is reclining, the invisible cone-like sheets of catastrophic nothingness that extend out to infinity will partition the room into different regions.

It is well known that taking a viewpoint from near the feet or head can lead to more dramatic drawings due to fore-shortening of the figure, but the richer catastrophic structures that are visible from these locations also heighten the visual interest.

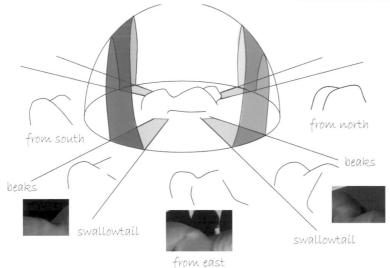

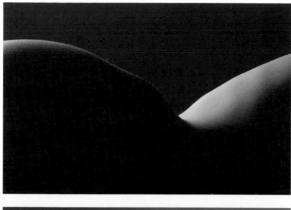

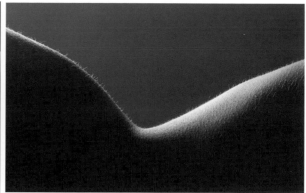

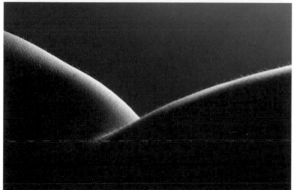

When I have explained this to life models, they have generally liked this idea that their bodies project out these catastrophic sheets that permeate and partition the surrounding room; it adds to their feeling of being active participants in control of the space.

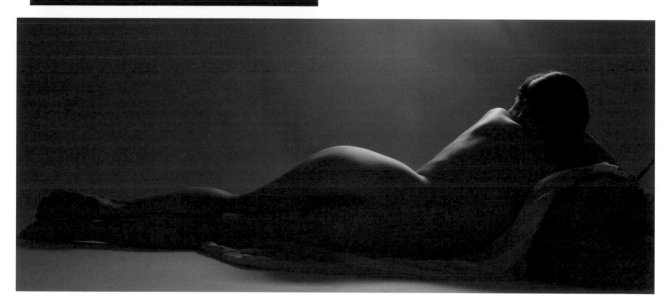

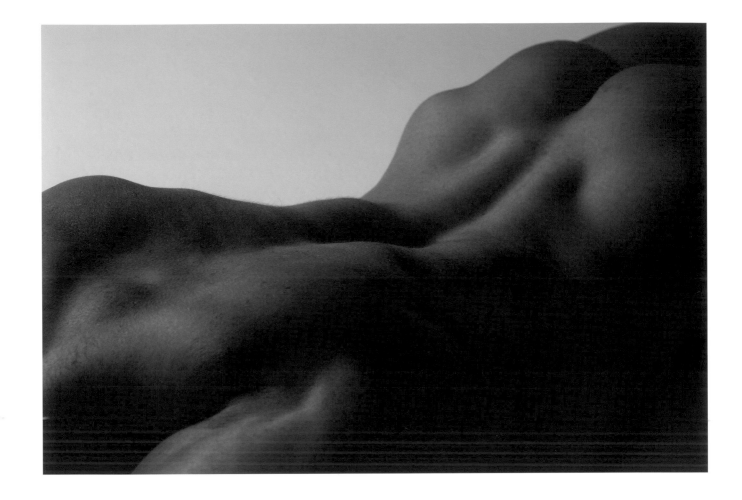

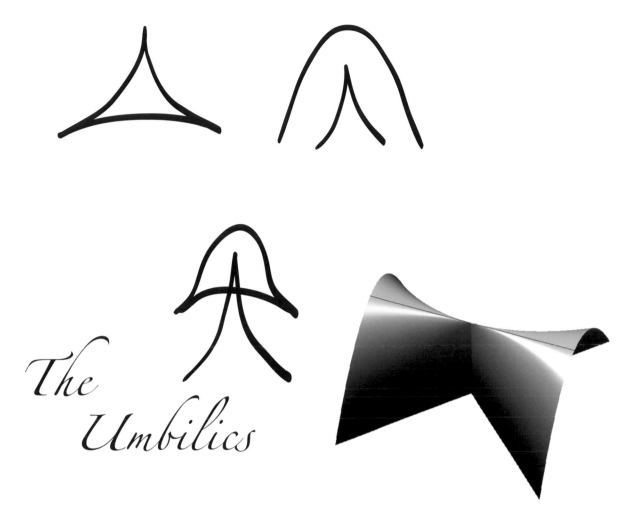

The Umbilics

Three of Thom's Seven Elementary Catastrophes cannot be seen in the life class. These are the umbilics, the two main ones being the elliptic and the hyperbolic, with the third, the parabolic, being less common.

The reason they cannot be seen on the outlines of a human body is that in 3D they would require the surface—or skin—to be able to pass through itself, and the skin of a life model simply cannot do that. However, sheets of light and the abstract mathematical surfaces that underlie the theory of stability have no such difficulty.

First let us tackle the issue of self-intersection. Typically, the umbilics we shall encounter involve 2D-in-4D manifolds,

and in the higher-dimensional 4D space there is much more room so that self-intersection can be avoided. But 4D spaces are difficult to visualize, and even more difficult to draw on the pages of a book, so we shall begin with a simple 2D-in-3D surface that intersects itself—the *Whitney Umbrella*.

A Whitney Umbrella can be readily made from a sheet of paper by putting a cut in it, folding it over, and regluing it along the cut. In 3D, the Whitney Umbrella is not a manifold because it is not smooth everywhere. There is a single point at the top of the reglued cut, the line of self-intersection, where the curvature is infinite. However, this lack of smoothness can be easily removed if we embed the

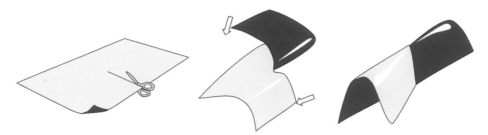

umbrella in 4D rather than 3D. We have already seen how projecting down from a higher dimension to a lower dimension can create singularities and sharpness, like in the photos of the bent wire. Well, this is the same but in reverse—we have a lack of smoothness in 3D, but we can consider the sharpness to have arisen by taking a smooth 2D-in-4D object and projecting down to 3D.

Thom's mathematics gets its power by looking at surfaces that are not only smooth but also irregular, generic. They are not flat surfaces like the sheet of paper, so to make our umbrella generic, we shall make it out of stretchy rubber sheet. (Actually the paper would already need to have been a little bit stretchy for us to fan out the ends of the umbrella as in the diagram above.)

The two simplest ways to deform a rubber-sheet umbrella are to curve its ridge-line either downward or upward.

The downward-curving ridge leads us to the *hyperbolic umbilic*, several views of which are shown below (right).

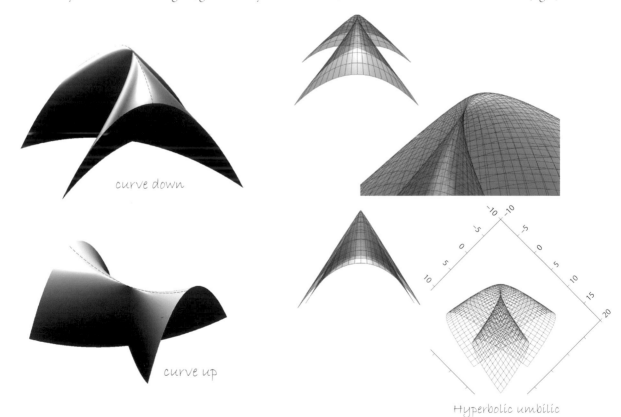

curve down

curve up

Hyperbolic umbilic

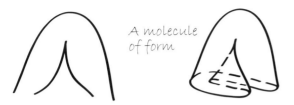

A molecule of form

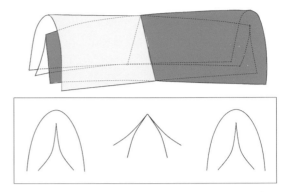

The characteristic pattern just away from the hyperbolic umbilic has an inner cusp with an encompassing fold. Such a pattern is a "molecule" of form and can be readily found in the life class. However, with real skin, it is impossible for the cusp to actually collide with the fold as it does at a hyperbolic umbilic.

A Whitney Umbrella can be found at the top of a *cross-cap*, a strange object much used by topologists. A cross-cap is actually just an unusual manifestation of a Möbius strip. Looking at this top part of the cross-cap from varying directions will reveal the hyperbolic umbilic.

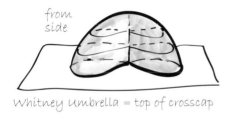

from side

Whitney Umbrella = top of crosscap

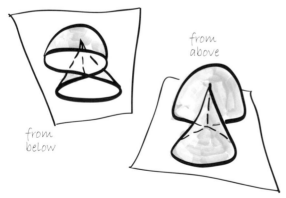

from above

from below

If we take all the line diagrams from a sequence of views passing through the hyperbolic umbilic and paste them side by side to create a new object, we obtain the following picture.

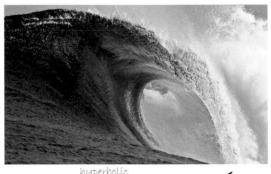

Slices through this reveal the characteristic cusp-with-surrounding-fold and show how the fold (colored orange to the right) passes through the catastrophe and emerges to the left with a cusp on it.

Thom proposed this as a description of how waves break. First the wave has a smooth rounded crest, like the fold line. This evolves through the hyperbolic umbilic to obtain a cusped-peak that subsequently tips forward to form the sharp crest of the breaker. Although there are a number of singularities in wave mechanics, I believe that physicists do not agree with the specifics of this particular interpretation.

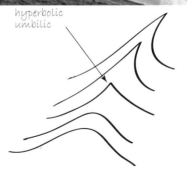

hyperbolic umbilic

The other main umbilic is the *elliptic umbilic*, and this may be found by taking views along the ridge of an upwardly curving Whitney Umbrella. The catastrophe itself is a single point, but just away from there it reveals its characteristic line diagram, the curvilinear triangle carrying a cusp at each corner.

Before the catastrophe there is a three-cusped star that shrinks to a point at the umbilic itself. Beyond the catastrophe, another three-cusped star is born. Although the before and after diagrams look identical, the cusps are on different parts of the umbrella roof.

Again, the union of all the line diagrams creates a catastrophe surface, slices through which reveal the sequence of the unfolding.

Thom, for reasons that perhaps only he understood, proposed that the elliptic umbilic had a role to play in hydrodynamic jets, flagella, hair, and hedgehog spikes.

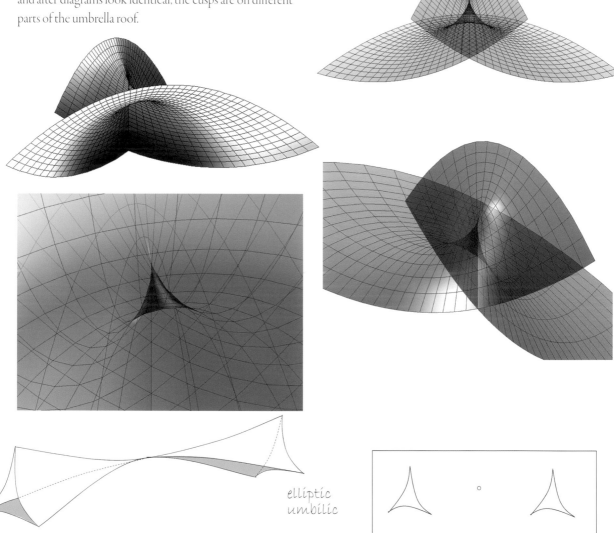

elliptic umbilic

The *parabolic* umbilic is the most complicated of Thom's Seven Elementary Catastrophes. To see one, take a Whitney Umbrella and rather than curving the ridge all upward or all downward, bend it up to the left and down to the right. This adds a cubic rather than a quadratic term along the ridge direction. A view directly along the ridge then reveals a rather uninteresting single dot at the parabolic umbilic itself, but more interesting catastrophic structures are found by "unfolding the catastrophe" by looking along the ridge at different angles. Even this does not reveal all the morphological possibilities. Looking from different angles corresponds to adding only linear perturbations, but by arching the whole

ridge-line up or down a little, varying degrees of quadratic perturbation can also be added. There is thus a 2D space of possible unfoldings parameterized by the varying amounts of linear and quadratic perturbations. The figures below, taken from *Structural Stability and Morphogenesis*, show the possible unfoldings of a parabolic umbilic.

Overleaf are two figures showing possible views along the warped ridge of the umbrella, with the final diagram giving perhaps the clearest indication that a parabolic umbilic involves the collision of the more common elliptic and hyperbolic varieties, as a three-cornered star is about to form when the central cusps collide in hyperbolic fashion.

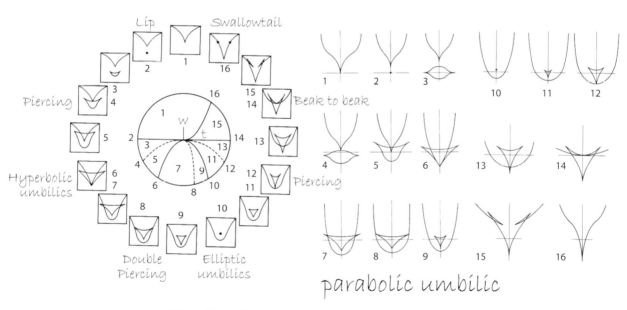

René Thom, unfoldings of the parabolic umbilic catastrophe. From *Structural Stability and Morphogenesis* (Reading, MA: W.A. Benjamin, 1975).

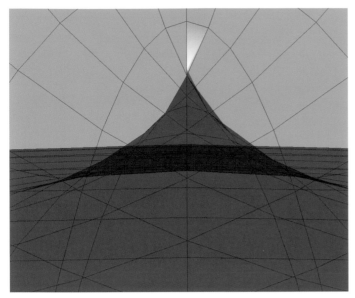

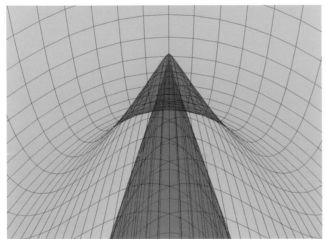

That then completes the introduction to Thom's Seven Elementary Catastrophes, comprising four cuspoids and three umbilics. These are the simplest animals in the zoo of possibilities. There are more exotic beasts such as the umbilic bracelet, the astroid, and the symbolic umbilic. In fact, the list is endless.

And just as the life class was used earlier to exhibit the four cuspoids, we shall use the swimming pool floor as the canvas for the umbilics. The swimming pool is a nice place to observe all seven of Thom's Elementary Catastrophes.

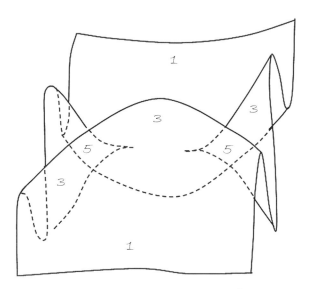

Catastrophe Optics

The field of optics provides one of the richest applications of catastrophe theory, and one of the most beautiful. Sunlight bouncing off a river onto the underside of a bridge or the side of a boat can create flickering patterns of brightness, and similar patterns dance across the floors of swimming pools. The phenomenon is known as the natural focusing of light, and it refers to the patterns made when light bounces off smooth, curved, irregular surfaces or is bent as it passes through natural lenses of glass or water.

Early in his studies of singularities Thom had observed with some amazement how the shimmering patterns of reflected and refracted light not only were beautiful but contained a grammar of shape—the same tantalizing patterns of folds and cusps kept emerging no matter how irregular the distorting surface. It was in such experiments that Thom first observed the umbilic catastrophes—shapes that are difficult to see in the life class but that reveal themselves readily whenever light is focused by a natural surface.[13]

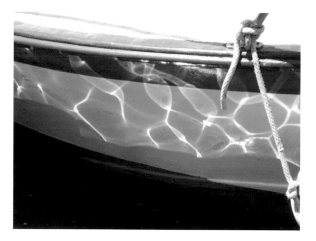

To see how catastrophe theory applies to these patterns, observe first how the irregular bending of light leads to a fold. We track a sheet of parallel light—sunlight through an open window—as it passes through a distorting surface of rippling water and emerges folded on the far side before it

hits the floor. This folding means that some parts of the pool floor receive light from three different directions, and the folds are revealed on the pool floor as bright edges of the region of threeness.

That is the simplest arrangement, back-to-back folds creating an S, leading to a stripe of oneness, threeness, oneness on the floor. Obviously, given that the water surface can carry quite complicated wave patterns, the possible catastrophe patterns on the floor can be rich in structure.

In the photograph to the right, the bright stripes are thus regions of threeness, edged with folds that are bright against

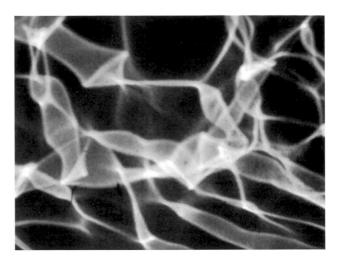

the darker oneness. Closer inspection reveals further details, such as a lips transition crossing the region between folds, each cusp about to collide with the folds at a hyperbolic umbilic. And there is a butterfly nearby.

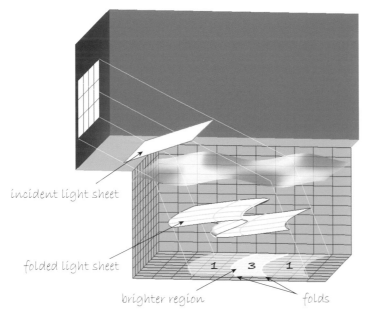

incident light sheet

folded light sheet

brighter region 1 3 1 folds

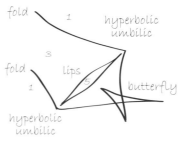

fold 1 hyperbolic umbilic

fold 3 lips 5 butterfly

1

hyperbolic umbilic

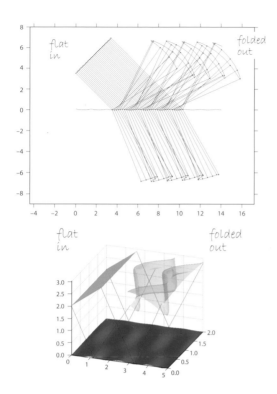

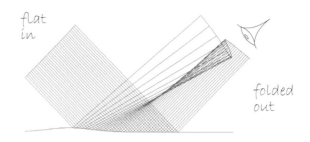

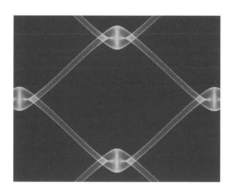

Of course, as well as the fraction of light heading down to the pool floor or seabed, there is a proportion that is reflected back upward. Again, we can think of this as a light sheet being stretched and folded after its reflection by the undulating water surface, and it leads to the lovely, dancing patterns of light on the sides of boats in sunny harbors, as in the photograph at the start of this chapter.

Alternatively, you may be sitting on a clifftop, looking down on a twinkling sea. How many twinkles are there? It is clear that the eye in the drawing above will see three images of the sun because it is in the folded-over region above the cusp, and so light is arriving from three different directions. Outside this region the eye would see just the single reflection of the sun. And so if you see hundreds of bright twinkles, it means the light sheet has been folded over many times to be hundreds of layers thick before it reaches you.[14]

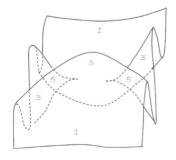

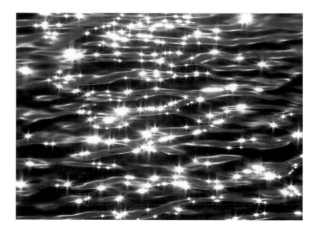

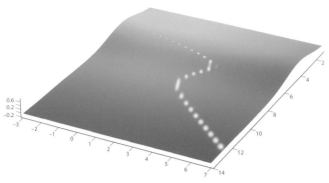

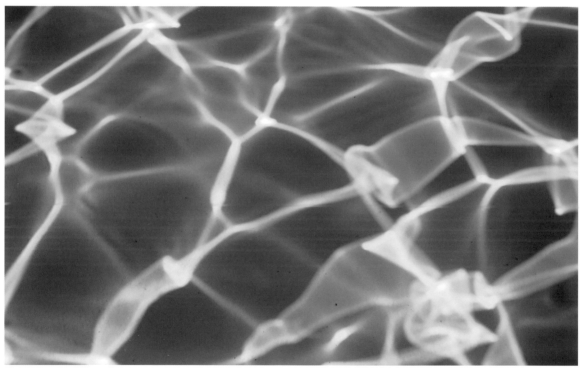

The figure above shows the reflection of a row of lights by a water surface with a single wave, but it equally illustrates what happens when a single light—the sun, say—is reflected by a passing wave. We start at the bottom corner, with a single upside-down reflection. As the wave approaches, two further images—a sun and an anti-sun—are suddenly born out of nothingness near the crest of the wave. And so now you see three suns. The central, right-way-up sun then travels down the face of the wave to collide with the original anti-sun at a fold catastrophe, leaving just the remaining anti-sun beyond the crest. Your eye has observed the passage of back-to-back folds that form an S. You saw oneness, then three-ness, then oneness.

Walk down a city street and you will be surrounded by the man-made rectangles and circles of Euclid. Sit on a beach and the natural world will speak the language of Thom.

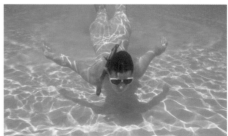

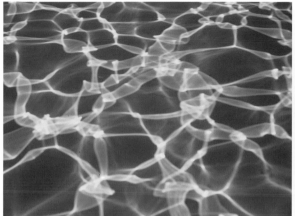

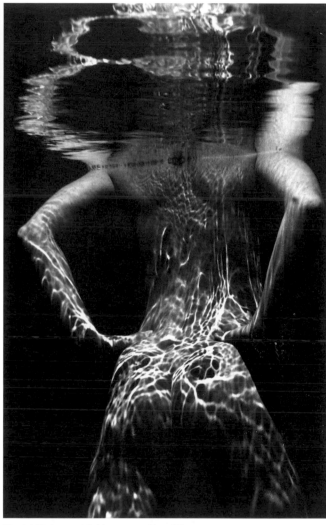

Untitled (Underwater Nude), circa 1979, Brett Weston.

Throughout this chapter we have made the simplifying assumption of geometric Newtonian optics: that light travels in straight lines. Light, though, has a wavelike nature, and if this is included in all our foregoing discussions, the picture changes somewhat—the infinities disappear and hard edges become adorned with undulating ripples. The work that pioneered this improved understanding of catastrophe optics took place at the University of Bristol in the 1970s, spearheaded by Michael Berry and with considerable input from John Nye, John Hannay, and others. I happened to be an undergraduate physics student there at the time. My final year project was an attempt to use holography for optical character recognition. In the back of my mind was the hope that this work might one day lead to a machine that could read books or bankcards. I did wonder, though, what the underlying intention was of the students in the laser dark room next to mine, who seemed to be spending their final year simply bouncing laser beams off water droplets and photographing the results. In retrospect, I recognize the profundity and importance of their work, conducted under the guidance of Michael Berry.

In our geometric description of a folded light sheet, the light intensity at the fold line is theoretically infinite. In the more detailed wave mechanics analysis, though, the fold line becomes a region of high but oscillatory intensity, and the infinities at cusps break up into bright (but finite) mottled patterns. The complex oscillatory integrals, developed and solved by Michael Berry, lead to patterns having a near-perfect match with the experimental photographs.[15]

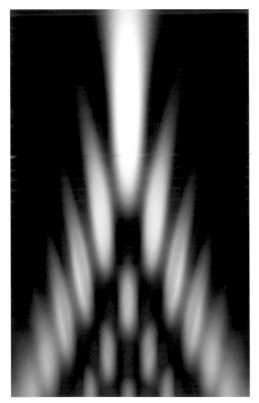

Cusp (theory) by Michael Berry.

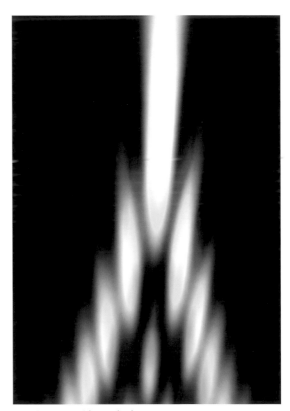

Cusp (experiment) by Michael Berry.

Do not all charms fly
At the mere touch of cold philosophy?
There was an awful rainbow once in heaven:
We know her woof, her texture; she is given
In the dull catalogue of common things.
Philosophy will clip an Angel's wings,
Conquer all mysteries by rule and line,
Empty the haunted air, and gnomed mine—
Unweave a rainbow …

—from *Lamia* by John Keats, 1819

The Rainbow

A caustic diagram by Leonardo da Vinci. A selection of notes on mathematics and other subjects, with architectural drawings, from the hand of Leonardo da Vinci, commencing in 1508.

The name "catastrophe theory" may be heavy with portentous connotations of foreboding, and yet we have seen that it involves itself with many beautiful things. It applies to the shape of the human body, to the patterns of light on swimming pool floors, and to boats moored in sunny harbors. It even applies to a sparkling sea. And we add to this list of almost magical beauteousness by showing that the rainbow is actually a fold catastrophe.

Leonardo da Vinci had noticed the cusped shape of the caustic caused by sunshine reflecting from the inside of circular cups or glasses. He did not notice that the optics of the rainbow is decidedly similar. We shall extend the lines in his diagrams above.

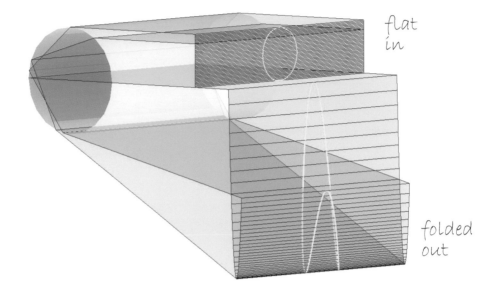

flat
in

folded
out

Begin by shining a light sheet into the top half of a glass cylinder. The light is bent as it enters the front surface, before being reflected from the rear surface—much as in Leonardo's teacup. Some rays, though, are reflected twice before they finally leave the front surface, and this process puts a fold into the light sheet. Above, we shine in a picture of a yellow circle, and it emerges folded in two, much like a Salvador Dalí clock.

The light intensity emerging along the fold line will be very bright. In fact, in this simple geometrical explanation it is theoretically infinite there. This means that someone viewing the cylinder from a direction along the fold line will see a brilliant stripe of light, while other views will be considerably more ordinary.

You can do the experiment next time you are enjoying a glass of wine in the sunshine. Sit with your back to the sun, and hold the wine glass out at arm's length in front of you. Then sweep from left to right and observe the stem of the glass. When the glass is at approximately forty-five degrees to either side, you should see a brilliant flash of red light emerging from one side of the stem. Be careful not to hurt your eyes.

Having so located the fold angle, you can look more closely and watch how, as you move the glass slowly back and forth through the fold, you can see two bright spots slowly getting closer to each other, finally hitting each other at the fold with a brilliant red flash. It is a strikingly beautiful example of a fold, and one that you can fold and unfold at your leisure.

Now replace the cylinder with a glass sphere. By the same process of refractions and reflections, a flat light sheet entering the sphere will emerge as a disk with its edge folded inward—like an unworn beret—and viewers anywhere along the cone formed by the fold directions will see a brilliant internal reflection.

Imagine now standing in front of a wall covered in small glass spheres, lit by a bright point of light behind you. Generally you will just see a flat wall—except that there will be a circular arc shining out brightly, this being all the spheres where your eye lies along the fold angle. This is the arc of the rainbow.

All that remains is to add the colors. These arise because as the light enters and leaves the front surface it is refracted by differing angles depending on the wavelength of the light. It is the classical spectrum prism effect, like on the cover of *Dark Side of the Moon*. The result is that each color has a slightly different cone of emerging fold lines. The cone of red light emerges at the widest angle, so the bright arc on the wall in front of you will be red along its upper edge, with the other colors laid out in sequence inside this. Just like a real rainbow.

This may seem like a fairly long-winded explanation—going from the cylindrical wineglass stem to the glass spheres—and it may seem like the only thing we have shown is the angle at which you see the rainbow arc. But it is neater than that. The wineglass stem allows you to really see the fold. I have just done this in my kitchen. In my kitchen there are quite a few white LED lights, and so when I hold up a wineglass I can see lots of little white lights reflected in the stem. And when I move the glass around in front of me, I can watch as two of the little white dots get closer together and then rather magically disappear in a puff of unexpected color. You really can see the rainbow as a fold, a little twinkle of color at the point at which twoness becomes zeroness. Or at which zeroness becomes twoness.

The photograph above shows a double rainbow over Sir Isaac Newton's cottage, Woolsthorpe Manor, in Lincolnshire.[16] There is a lovely resonance in this picture since it was Newton who first determined that white light was made up of all the different colors of the spectrum. He passed white light through a prism to obtain a rainbow and then recombined the colors to obtain white light again. It was an important event in the

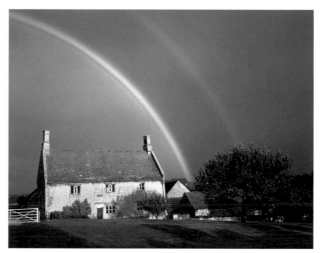

A double rainbow over Isaac Newton's family home in Woolsthorpe-by-Colsterworth, Lincolnshire, England. Photograph by Professor Roy L. Bishop.

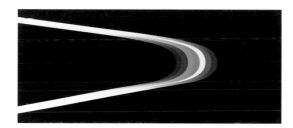

history of science. Until then, Descartes' theory of light had held sway. Descartes believed white light to be pure, and not a combination of all the colors, and Newton's simple experiment revealed this to be untrue.

Newton, Hooke, Descartes, and Leibniz were leading figures in the Enlightenment, a period around the seventeenth century during which science underwent an extraordinary burst of progress. That progress has continued largely unabated to the present day, even in the face of considerable opposition from various quarters, including organized religions. One such vigorous anti-science movement—the Romantic Backlash—emerged in the eighteenth century, and it included various poets, writers, and artists such as Wordsworth, Coleridge, and Keats. One of the main charges they leveled was that science was dehumanizing and lacking in spiritual and emotional intensity. Somehow science just took everything to pieces whereas the Romantics insisted that there was something altogether more fabulous about a living, thinking human than it being a mere clinical collection of bones, blood pumps, and other gadgets. They argued that the real mystery lay in whatever it is that makes the whole greater than the sum of its parts. John Keats—who as well as being a poet was a licensed physician—expressed some of these ideas in his poem *Lamia*. According to Keats, science—made "all charms fly at the mere touch" and placed the rainbow in a "dull catalogue" as the scientists "conquer all mysteries." Anyone who explains a rainbow, according to Keats, is not only guilty of unweaving its magic and mystery but is part of a larger movement of philistinism that is incapable of appreciating the beauty and majesty of the mysteries of life, the Universe, and, to finish the phrase, everything. This charge of "unweaving the rainbow" has been rebutted by various defenders of science—particularly Richard Dawkins, who has a book of that title. But is your response to a rainbow in any way lessened by knowing it shares a language with other beautiful forms?

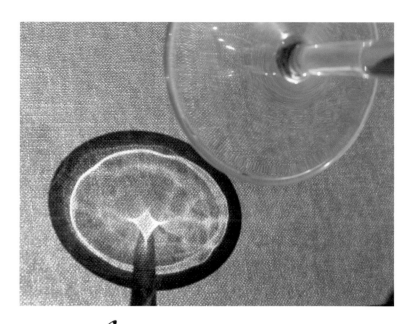

Gravitational Lenses

When I am in a fancy restaurant, I have an annoying habit of playing with the shapes made on the tablecloth by light passing through the base of my wineglass. I really am listening to what my wife is saying, but I am also just enjoying the patterns.

One of my favorite patterns is the astroid, a curvilinear square with a cusp at each corner, a sort of four-cusp version of the three-cusp elliptic umbilic. And like the elliptic, the actual astroid is a single point, and its pin-cushion shape is obtained by unfolding it.

This pattern crops up rather often, even though it is not one of Thom's Seven, those being the catastrophes that we expect to encounter most frequently. The reason is symmetry. Thom's Seven were developed for the general case, for organic blobs with no symmetry. If you add symmetry you can start to encounter catastrophes that would otherwise be more rare. The wineglass base is not a generic blob—it has circular symmetry.

We have already encountered the four-cusped astroid in the evolute of the buoyancy locus of the oil rig stability problem, although the corner cusps there were sometimes augmented into butterfly morphologies.

A question that arises in astronomy is, "How do you weigh a supercluster of galaxies?" It is quite a difficult

problem. The supercluster may be zillions of miles away, trillions of miles across, and contain gazillions of stars, and the only information available may be a photograph of it. Well, rather remarkably, the wineglass can help.

In his theory of general relativity, Einstein showed that light is bent as it passes a heavy object. Actually, this is not exactly true. Essentially the light still travels in what it thinks are straight lines—it is just that the space time is curved near the heavy object, and just as an ant trying to walk straight on the surface of an apple ends up walking in a curve, so a ray of light appears to be bent.

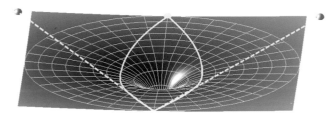

Light from a star behind a heavy object, like a black hole, is bent and focused as it passes, and a viewer at the front will see light arriving from two directions. Well, actually, given the radial symmetry, the viewer will see a whole circle of light, like a halo around the black hole.

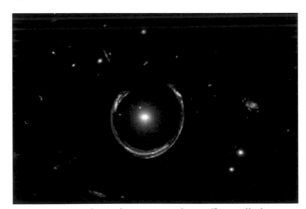

The picture above shows just such an effect, called an *Einstein ring*. The outer ring is the image of a second distant star that would otherwise be hidden behind the heavy star in the center foreground.

The equations of general relativity are really rather difficult, but we can replicate the phenomenon quite accurately by replacing the foreground star by a simple lens, albeit a very big one. Think of it as a plate of bulbous glass stretching across the sky, distorting the appearance of background objects. The next diagram illustrates the general scheme of things. A sheet of light passing through the glass is folded over in the central region to become three layers thick.

If the viewer is far off-axis (at A, say), he will see just one image of the background star over to the left. This image may be somewhat crescent shaped.

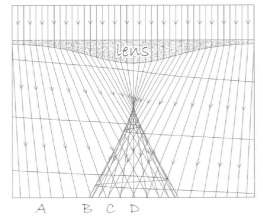

As the viewer moves inward, he passes through a fold catastrophe at B. Here a very bright second image of the background star will appear over to the right. This then will split immediately into a crescent-shaped outer image and a dimmer, more central image. Two (apparent) stars were thus born out of nothingness as the viewer passed through the classic oneness-to-threeness sequence of a fold.

Moving further inward yet, toward the highly degenerate central point D, the left and right outer crescents grow in size until, at D, they meet at the top and bottom to create the full Einstein ring. Meanwhile, the fainter central image heads ever more centrally until it disappears behind the foreground star.

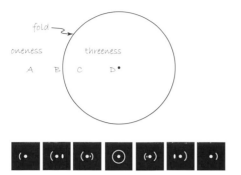

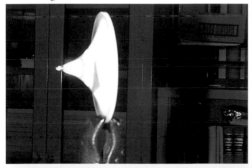

The main picture above shows the pattern that would be seen if there were some giant intergalactic tablecloth, and the sequence of smaller images shows what the viewer sees as he moves across the tablecloth.[17]

It is clear that we are really just doing wineglass optics, and the following photographs show how gravitational lensing can be readily reproduced in the lab with a specially designed piece of glass, a piece that is actually little more than a glorified wineglass base.

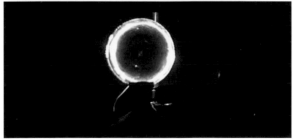

If the foreground object is somewhat ellipsoidal rather than perfectly spherical, the radial symmetry is broken. The outer fold line B becomes somewhat elliptical but is basically still just a simple circumscribing fold. The central degenerate point D, however, evolves from being a single point, becoming an astroid with its characteristic four-cusped fold line.

As the viewer crosses from the threeness region near C into this central region of fiveness, two more images are born. Rather than seeing an Einstein ring, the viewer will see an Einstein cross.

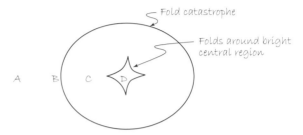

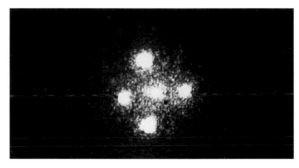

There are now a total of five images of the background star, but the central one is obscured by the foreground star.

In the restaurant, the symmetry-breaking can be achieved by aligning the wineglass base at an angle to the light above. Indeed, that is usually the case; this is why we so readily see the four-cusped astroid on the tablecloth. Maybe those heavy-drinking poets had a point—perhaps there is profundity to be had by looking at the Universe through the bottom of a glass.

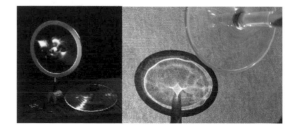

The previous photograph of the Einstein cross, taken by the Hubble Space Telescope, provides a lot of information about the foreground star. It must be a very massive object, given the large degree of bending observed. And the mass distribution cannot be perfectly spherical because there is an Einstein cross rather than an Einstein ring or the partial crescents thereof. In fact, the foreground object is not a star at all—it is a galaxy. And the background object is a quasar.

This idea that the distortion of background objects reveals a great deal about the foreground object can be put to telling effect and can be used to perform the rather remarkable feat of weighing a cluster of galaxies.

I think this is one of mankind's truly great achievements and it is something to ponder upon, next time you look up into a starry sky. Out there are clusters of galaxies. Each star is unbelievably big. Each galaxy contains an inconceivably large number of stars and each cluster may contain thousands of galaxies. Their size and power are almost beyond comprehension, and yet because they are so unimaginably far away you can't even see them. Something so big is not even a faint dot. But even so, despite your own shortcomings, some of your fellow humans have not only seen these things, they have actually weighed them.

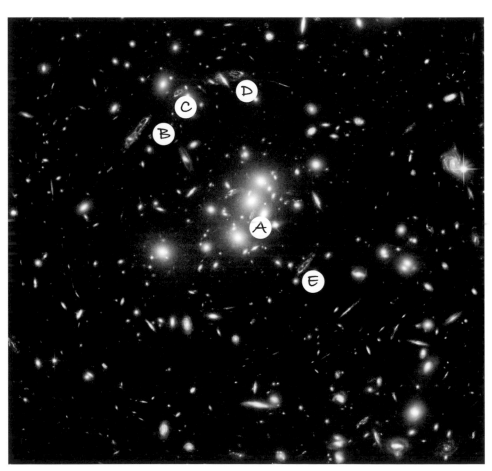

Gravitational lensing by galactic cluster Pisces CL0024.

The picture opposite, again taken with the Hubble, shows a remarkable photograph of the galactic cluster Pisces CL0024; these galaxies are the larger, bright yellowish patches near the center of the picture. In the background, also central, a more distant, slightly blue-tinged galaxy, marked A, is barely visible between the foreground galaxies. Remarkably, at least four other images of this background galaxy appear in the photograph, marked B–E. Images B, C, and D lie on an arc, and C is reversed relative to B and D, just as one would expect for a twice-folded morphology. It is essentially an Einstein cross arrangement, with the fifth (usually hidden) central image, rather unusually here, being visible through gaps in the foreground object.

There are many more lensed objects in the photograph. These appear as thin, smeared stripes that appear to circle the central cluster, such as the stripe to the right of D and the thin arcs diagonally below and right of E.

As before, the distorted and repeated images of the background objects give a lot of information about the mass distribution of the foreground galaxies. Computer analysis of this image by astronomers has revealed a rather detailed map of the foreground mass distribution, as shown to the right here. This is how the mass must be distributed in order to create the observed bending of the light.

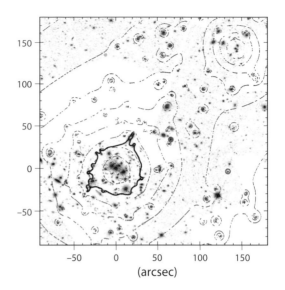

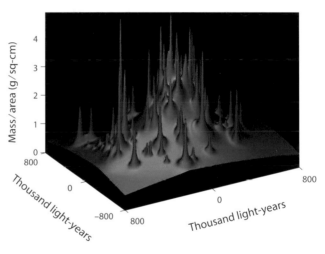

The geometric optics of gravitational lensing.

Gravitational Lensing:

1. A Distant Source
Light leaves a young, star-forming blue galaxy near the edge of the visible universe.

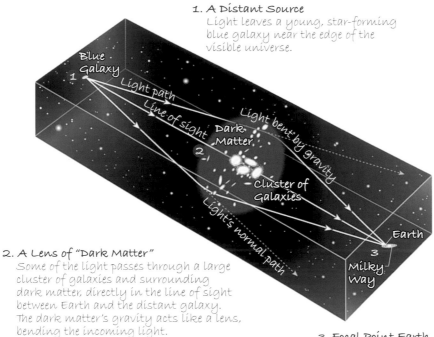

Blue Galaxy
1
Light path
Line of sight
Dark Matter
2
Light bent by gravity
Cluster of Galaxies
Light's normal path
Earth
3
Milky Way

2. A Lens of "Dark Matter"
Some of the light passes through a large cluster of galaxies and surrounding dark matter, directly in the line of sight between Earth and the distant galaxy. The dark matter's gravity acts like a lens, bending the incoming light.

3. Focal Point Earth
Most of this light is scattered, but some is focused and directed toward Earth. Observers see multiple, distorted images of the background galaxy.

Tony Tyson, Greg Kochanski, and Ian dell'Antonio. Illustration from "Gravitational Lensing: A Trick of Light" by Frank O'Connell and Jim McManus © The New York Times, December 29, 1998.

This is impressive work, but there is an even deeper twist. Astronomers have a fairly good idea of how many stars there are in a galaxy and how much they weigh, so they already had a reasonably accurate idea of how much mass they were expecting to find in such a galactic cluster. But the lensing calculations say that the light has been bent far more than would be expected. The implication is that there is much more mass present that does not manifest itself in the form of visible stars. This extra mass, they hypothesize, is in the form of *dark matter*. This is a mysterious substance that has never been observed in the laboratory but seems to be out there in the wider Universe. Current estimates suggest that there is actually more than five times as much dark matter as there is ordinary matter.

As a result of other observations and theories, astronomers hypothesize that there is also a third substance, *dark energy*, and that there is twice as much of this as there is dark matter. Matter, it seems, makes up a mere 5 percent of the stuff in the Universe, and the gravitational lensing calculations are an important part of the evidence that this is not pure poppycock conjecture on the part of astronomers.

And if that were not enough for one day, gravitational lensing also turns out to be a powerful way of locating planets orbiting around distant stars. It is a process known as microlensing.[18]

Imagine two stars aligned with a viewer here on Earth, and that the foreground star is orbited by a heavy, Jupiter-like planet. Without the planet, the viewer on Earth would expect to see the foreground star garlanded with a faint Einstein ring. However, the planet's mass disrupts the radial symmetry of the problem, and so—depending where the planet is—the perfect ring breaks up into a sequence of arcs or even an Einstein cross. The actual details may be too close to the central star to be successfully resolved in detail by even the Hubble telescope, but a measurement of the apparent brightness of the whole system over time can be very revealing.

Imagine the Earth sits on a big intergalactic tablecloth, that the background star is the spotlight in the restaurant ceiling, and that the foreground star is the wineglass base. The disruption of the radial symmetry by the orbiting planet is then akin to gently tilting the wineglass back and forth. In so doing, the pattern of bright fold lines will move slowly around the tablecloth. If a fold line crosses the Earth, the viewer there will detect a sudden change in brightness.

We can readily predict the change in brightness that will occur when a twice-folded wave crosses the viewer on the tablecloth. Not only will the brightness increase as the region of threeness hits—because there will then be three layers of light sheet rather than the original one—but there will be a sharp increase in brightness as the fold lines pass across, due to the way the light rays bunch up at a fold. We have already seen this in the swimming pool floor patterns, the brighter regions of threeness shining brightest at their fold-line edges. And it is the reason the rainbow—a fold—shines out brightly against the background sky.

Consider now the data that emerged from one of the OGLE experiments undertaken by a team of Polish astronomers working with a telescope in Chile that was pointed at just such a system. Over a period of hours the light intensity suddenly spiked, fell back to a level that was still higher than the original, and then rose again to another spike before finally falling back to values in line with the original readings. It is exactly what you would observe from a swimming pool floor if a region of threeness passed over you. From this information, the astronomers can not only infer the existence of a planet around this star, they can calculate many detailed properties of its orbit and mass.

When I give talks about the overlaps that exist between catastrophe theory and art, some hard-headed member of the audience, usually a scientist, is often wont to ask: "What is the use of all this?"

Asking what is the use of, say, a swallowtail is like asking what is the use of a pentagon. And even so, if weighing a cluster of galaxies, providing evidence for the existence of dark matter, and discovering other, potentially Earth-like, planets is not sufficient use, then I do not know what is. In *Critique of*

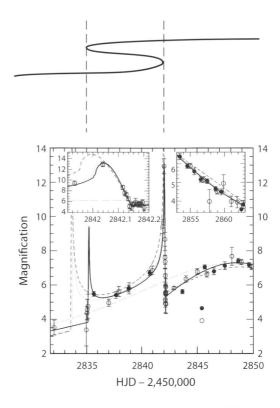

Results from the OGLE experiment. The twin peaks in light intensity correspond to the fold lines that bound the region of threeness of a twice-folded light sheet.

the Power of Aesthetic Judgement, Kant writes: "If the question is whether something is beautiful, one does not want to know whether there is anything that is or that could be at stake … but rather how we judge it in mere contemplation."[19]

Catastrophe theory is useful, but even if it wasn't, I would still find this beautiful.

Stability

We have already seen that there is an ambiguity in the title of Thom's book in his use of the phrase "structural stability." The stability he is referring to is exemplified by what we have called the Persistence of Cusps—if you can see a cusp on a surface, and you move your head a little, you will still see a cusp. That is, his shapes are robust. His shapes are also *generic*. They are the shapes you will naturally encounter in any exploration of smoothly curved manifolds.

This combination of robustness and generality is what he means by structural stability. But the more everyday meaning of "structural stability," which refers to why buildings do or do not collapse, also happens to be a subject whose underlying mathematics is full of smoothly curved manifolds. As a result, it is a rich arena for catastrophe theory, and like the field of catastrophe optics, it is one that throws out umbilics galore.

To find an umbilic in the theory of structural engineering we first need to generalize our earlier simple examples, our models of the column and the arch, by adding another mode of deformation.

In the earlier models, the structures could only deflect in one mode, a symmetric bow shape, but if we introduce another mode of deformation, our energy functions—which were previously 1D *curves*—now become 2D energy *surfaces*, and we can start to encounter a richer set of catastrophes.

If the second mode doesn't get involved, we can get an evolution from a sort of *U*-bowl to a sort of *W*-bowl, and nothing much has changed. It is still a transition from oneness (U) to threeness (W) in the first mode, just as before, and the second mode just watches.

However, if the second mode gets involved, and interacts with the first mode, then things can become more interesting.

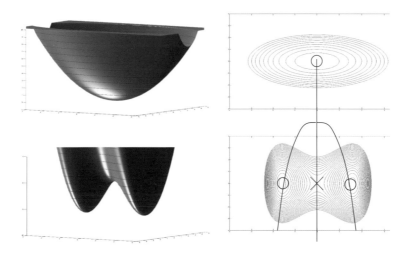

One possibility is that there is a curly W shape in the second direction as well, with the result that the main right and left depressions are still separated by a central peak, but the central peak is now flanked by side valleys.

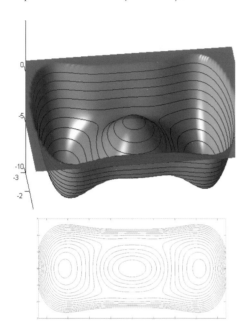

There are now five equilibria: two stable equilibria (left and right), an unstable central hilltop, and two side saddles that involve the second mode. As we change the load, the equilibria move, and one possibility is that the four equilibria on the left interact. Imagine tipping the whole energy surface slowly to the right. The well on the left will start to get shallower, and eventually the system will tip over into the right-hand well. However, rather than going straight over the central hilltop, as it used to do, it may now prefer to take a shortcut, taking a brief excursion around one of the side valleys.

It is possible to feel this with a train ticket or playing card arched between your thumb and forefinger. Pressing down in the center, as before, you may notice that it does not always snap through symmetrically but can wriggle briefly to the side as it snaps through, temporarily taking on something of an S-shape. That is, it starts to deflect in the symmetric mode, then notices that there is a lower energy side valley that it can

sneak around by taking an excursion through the asymmetric S-shaped mode, before finally returning to the fully symmetric mode deep in the second well.

Now that we are getting fluent at catastrophe theory, it is a good exercise to see if you can identify which catastrophe is involved when the four left-hand equilibria interact in this *hilltop branching* pattern.

The depression and central hilltop form a twoness, which can annihilate to zeroness via a *fold*. The depression and the two side valleys can interact via a oneness-to-threeness, which is the trident-like branching associated with a *cusp*. So we have a fold and a cusp. And so our guess would be that it is a hyperbolic umbilic that organizes all of this. And indeed it is.

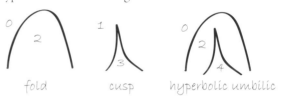

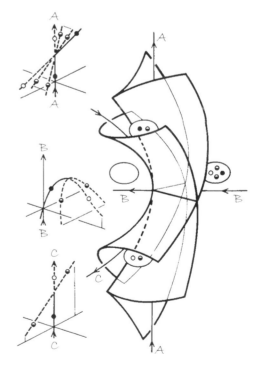

Hyperbolic umbilic (by Michael Thompson).

One would therefore hope that any structural engineer designing a shallow-arch bridge would have a good understanding of the possible unfoldings of a hyperbolic umbilic.

That was one example of a modal interaction problem. There are many other examples in the buckling of plates and shell structures. Other examples lead to elliptic, parabolic, and symbolic umbilics and to the double cusp whose unfolding contains the rather beautiful *umbilic bracelet*, a sort of Möbius strip of three-cusped stars.

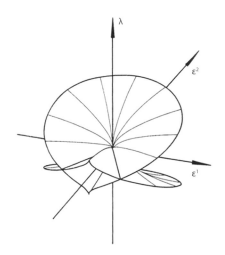

Hyperbolic umbilic (by Michael Thompson).

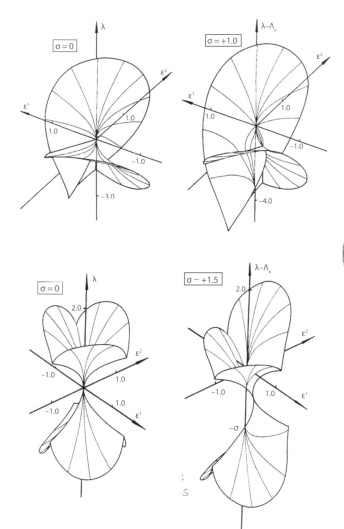

Elliptic umbilics (by Michael Thompson).

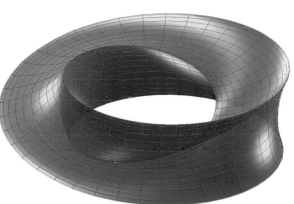

An umbilic bracelet

Morphogenesis

Morphogenesis is one of the outstanding unsolved problems in science. How does biological shape emerge in a growing organism? Given that every single cell in a body contains exactly the same set of genetic instructions encoded in its DNA, how do some cells know how to arrange themselves into hands and others into kidneys? And within the hand, some arrange themselves into bones, others into hair follicles, others into fingerprints. Somehow the cells at the end of each arm know that one has to make a left-handed version and the other a right-handed version, and even though they are millions of cells away from each other, and even though quite literally the left hand cannot see what the right hand is doing, they nevertheless do a remarkably good job of making mirror symmetric versions of each other.

In the unfolding storyline of this book, the first few chapters looked at how René Thom's shapes could be observed on the outline of the human body. That focus on the "visual events" was simply a device for learning the language of Thom's shapes. Beautiful though it may be, the fact that you can see a swallowtail on the waist of a human body is nowhere near as profound as the immense organization required to create all the components of that living, breathing, thinking human. Thom did not embark on his program of mathematics just to write a catalogue about vision, a catalogue that may be of use to researchers in computer vision. His ambitions were far deeper. He wanted to know how biological shapes emerged to be the shapes they finally become.

We can glimpse at least three possible ways that Thom's mathematics might have some role in all of this.

The first is that, during its early stages of development, the embryo is a pretty good example of an organic blob, a

bendy, stretchy, vaguely spherical thing that then starts to fold in on itself repeatedly. This folding process may create patterns in the early stages whose echoes manifest themselves recognizably at larger scales in the fully grown organism.

Second, spreading across this blob are chemical fields that are concentrated in some parts, less concentrated in others. The process involves fairly smooth concentration gradients somehow setting up sharp discontinuities. Cells that will form bones will end up being sharply separated from those forming soft tissues. Thom's mathematics is very much concerned with how smooth systems can exhibit discontinuous behavior. There could even be chemical frontiers spreading across the surface of the embryo, much like ink blots spreading across blotting paper. We have not looked at this yet, but a spreading frontier has much in common with an outline, in that it can begin to speak Thom's language, forming cusps and the like.

Third, at the microscopic level, it is all about energy. Chemical and molecular systems will tend to adopt the state of lowest energy. The chapter on structural stability has shown that the points of lowest energy on a potential energy surface evolve and collide according to the rules of catastrophe theory. Whether it is the energy of an arch bridge that is about to buckle or the energy of a protein that is in the process of folding itself into any one of a number of possible configurations, catastrophe theory provides a global overview of the set of possibilities and indicates which path will be followed.

In *Structural Stability and Morphogenesis* there is a chapter titled "Local Models in Embryology," a subsection of which is "Genital Chreods." When I first saw this subheading, I had already learned that a "chreod" was a sort of pathway through the space of possible shapes that might emerge in some biological growth process, and I assumed the word "genital" was an abstract reference to genesis, much in the way that "seminal" has a number of meanings. However, as I continued

reading I realized that, no, Thom had actually devoted a section of his book of mathematics to the age-old question of the shape of the genitals. Why are the genitals the shape that they are?

Thom's meaning is not particularly clear to me, and the best I can do is to say what I think he is saying on this subject. His arguments seem to rest on considerations of symmetry. During early development, male and female embryos are physically indistinguishable, except at the submicroscopic level of DNA. At some point, though, there is a branching: male embryos develop in one direction and females develop in another. And throughout this, left-right symmetry is preserved in both cases.

There is also the issue of internal and external. One pathway, or chreod, leads to a protuberance with a channel inside it, and the other chreod leads to invagination.

It seems that by asking which catastrophe can serve as the organizing center for this system with two symmetries, one of which is broken to give the internal/external manifestations, and the other of which (the left-right symmetry) is preserved, Thom arrives at the proposal that there is an underlying parabolic umbilic.

He goes considerably further in detail. He has a "plan for the glans" and a proposal that purports to explain the formation of the clitoris, the closing of the urogenital sinus in the scrotum, and the development of the Müller's canal (which in females forms the Fallopian tubes, uterus, cervix, and upper vagina but is lost in males).

We reproduce his line diagrams here. In the text immediately before his "plan for the glans" Thom states, "Here again it is superfluous to remark on the similarity to the mushroom *Phallus impudicus*." He goes on to say that some aspects of the morphology "can be explained if we view copulation as reversible capture." I am not sure what that means, but it is perhaps the most remarkable sentence in all the books that are filed under structural engineering in my departmental library.

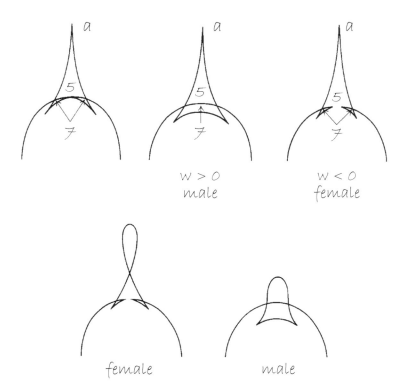

René Thom, "Local Models in Embryology," in *Structural Stability and Morphogenesis* (Reading, MA: W. A. Benjamin, 1975), chapter 9.

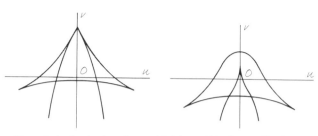

Thom: A plan for the glans. *Structural Stability and Morphogenesis* (Reading, MA: W. A. Benjamin, 1975).

continuous. There are the four digits A,C,G,T of the genome, triplets of which encode for the amino acids from which proteins are built. This is the discrete, the world of yes-no, on-off. And there is the continuous, the world of chemical gradients where concentrations vary smoothly across cells, organs, and organelles.

Ever since the discovery of the structure of DNA there has been such fabulous progress in the discrete description that it gives further sustenance to the argument put forward

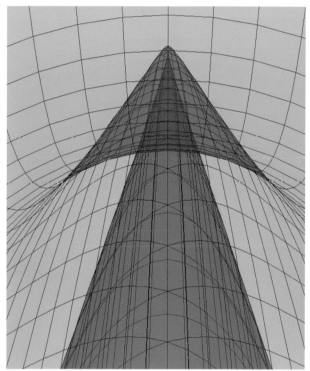

Phallus impudicus.

Thom goes on to say that his suggestions are "largely arbitrary" and that "any mathematician could construct simpler functions that were just as suggestive."[20] Nevertheless, he stands by his right to put forward suggestions that arise naturally from his theory of smooth functions augmented by arguments of symmetry and symmetry-breaking.

Generally, biologists are having none of this. In biology there is an obvious dichotomy between the discrete and the

by many eminent scientists in the 1970s that Thom's smooth mathematics, couched in its semimystical musings, can have little to offer the world of biology.

Many biological processes are now understood in detail as complex pathways involving myriad reactions, feedback loops, and chemical switches. Surely Thom's compendium of shapes is just too darned simplistic in the face of such complexity.

One imagines that Thom would have an answer, perhaps along the lines that—for all the details—there is a bigger picture. Work by professor of mathematics Jim Keener at the University of Utah deals with a simple case—called *quorum sensing*—where a group of bacteria need to sense how big their collective cluster is, so that if the colony is getting too large they can stop reproducing in order to remain undetected by the immune system. There is a complex system of chemical reaction pathways, the overall result of which is a switch controlling the release of a chemical, an auto-inducer, which can turn the colony growth on or off. And after all the complexity, this on-off switch can be seen to consist of nothing other than back-to-back folds forming the S-shape that is the icon of catastrophe theory.

$$\frac{dP}{dt} = k_{RA}RA - k_P P$$

$$\frac{dR}{dt} = -k_{RA}RA + k_P P - k_R R + k_1 r,$$

$$\frac{dA}{dt} = -k_{RA}RA + k_P P - k_2 L + k_A A,$$

$$\frac{dL}{dt} = k_3 l - k_l L,$$

$$\frac{dS}{dt} = k_4 s - k_S S,$$

$$\frac{ds}{dt} = V_s \frac{P}{K_s + P} - k_s s,$$

$$\frac{dr}{dt} = V_r \frac{P}{K_r + P} - k_r r + r_0,$$

$$\frac{dl}{dt} = V_l \frac{P}{K_l + P} \frac{1}{K_S + S} - k_l l + l_0$$

Chemical pathway reaction equations (James Keener).

The on-off switch for quorum sensing (James Keener).

There are theories for other switches in other complicated systems, where myriad chemical pathways are coupled together by nonlinear equations. Again proposals for back-to-back folds as the switching mechanism are put forward. Such proposals currently remain the realm of biomathematicians—of mathematicians who are working on biology but who have rarely been inside a laboratory. Biolo-

gists—who do spend their time in laboratories—have yet to agree with any of this.

To convince them, it would require some unambiguous experimental data showing that there are systems that exhibit multivalued possibilities within the switching region, a hysteresis loop. There is preliminary evidence of this in some protein folding experiments, but it is an almost impercepti-

ble fraction of the biological literature. Taken as a whole it has to be admitted that Thom's Big Picture has thus far failed to make any great inroad into the field of morphogenesis, even though this had been the prime motivator for Thom to embark on his program.

It is perhaps worth picking up on the earlier symmetry argument a bit. In its simplest form, catastrophe theory concerns itself with organic blobs that—like the surface of a smooth lump of clay—have no symmetry. They are irregular, generic. And in that setting, Thom's hierarchy holds. Folds will be common; cusps will be rarer; and so forth. However, if the system has some sort of symmetry then higher-order catastrophes that also possess that symmetry are more likely to be encountered on the plane of symmetry. We have already seen this with the perfect Euler column. It is the first example of buckling that any structural engineer ever meets, and yet it is not a fold; its classic trident-pronged bifurcation diagram is a slice through a cusp. So even though catastrophe theory says the first thing you will meet is a fold, structural engineers come straight in at cusp level. The explanation is that the perfect Euler column has left-right symmetry. When it buckles it is equally likely to go left or right. And so the bifurcation structure needs to exhibit that symmetry, and that is what pushes us up one level in the hierarchy.

The essence of Thom's argument is thus that, on the plane of symmetry of the body, we would expect to find catastrophes of higher order than folds because catastrophes there need to preserve left-right symmetry. He then adds a more abstract symmetry in the case of the sex organs—that the embryo should be able to bifurcate from its early hermaphroditic state into either the male or female form. He thus argues that the underlying catastrophe, the organizing center for this process, must exhibit these two symmetries, which therefore pushes us even further up the hierarchy. Thom's reasoning is that it pushes all the way up to the usually rather rare parabolic umbilic, which is then the simplest—and thus most natural—contender to be involved. It is a rather elegant argument. Bear in mind also that Thom is not talking about the visual events, about what we see; he is talking about the formation of the body parts governed by chemical processes. We could never see a parabolic umbilic on the body because that would require the skin to pass through itself. However, the chemical processes that govern the development could quite easily be governed by equations whose solutions live in some abstract four-dimensional space, whose projection— the physical manifestation of the process—yet bears the hallmarks of the symmetries of that catastrophe.

But as I said, biologists are currently having none of this.

Gabo

We turn now to catastrophes in the world of art. In a few moments we shall focus on one artist in particular, Naum Gabo, but first we take a brief—and necessarily incomplete—look at how an understanding of catastrophe theory may change the way you see art.

Nudes and blobs aplenty can be found in painting, sculpture, and photography. There is a branch of architecture known as "blobitecture," and one aspect of landscape design concerns itself with moving mountains to create outlines that are pleasing when they fall on retinas. All of this can be reexamined through the prism of our new understandings of form and the perception of form. It will not rewrite the Book of Art, but it will add something.

The list of artists whose work is worth revisiting with fresh, catastrophe-aware eyes is very long. Starting in antiquity, it is easy to see the simple drawings as lines of folds ending in cusps.

Moving forward many centuries, one can locate the swallowtails in the Velazquez and Titians, in the Bouguereaus of nineteenth-century Paris salons, and in the work of the Impressionists that followed. Thom's shapes are there—although you need to look carefully, in among all the subtle variations of color, shade, and tone.

Detail of cup showing a youth inside a bell-krater, Athens.

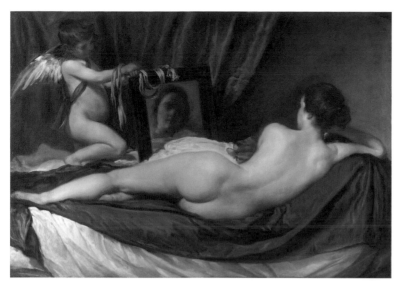

The Toilet of Venus ("The Rokeby Venus"), 1647–51, Diego Velázquez.

It gets very much easier as we march onward toward modernism, as photorealism gives way to quicker, simpler marks, as the artist actually draws the outline for you with a thick black brush stroke. The ends of lines are cusps, and post-swallowtail morphology reveals itself as a big black "y." They are there in Picasso's pre-cubist nudes and in the works of Matisse, and they are especially easy to observe in the cartoon-like pop art creations of Roy Lichtenstein.

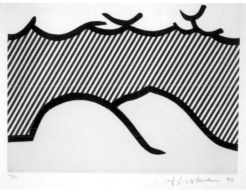

De Denver au Montana, Départ 27 Mai 1972, 1992 © Estate of Roy Lichtenstein/DACS 2016.

The Nymphaeum, 1878, by William-Adolphe Bouguereau.

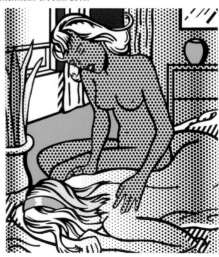

Two Nudes, 1994 © Estate of Roy Lichtenstein/DACS 2016.

Henri Matisse *Dance*, 1910 © 2017 Succession H. Matisse / Artists Rights Society (ARS), New York.

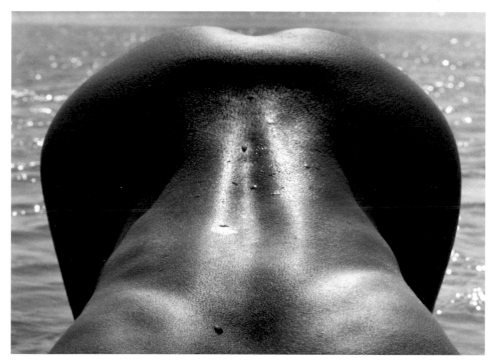

Nu de la Plage, Camargue, 1964,
by Lucien Clergue.

Photography has focused on more than its share of nudes, but given the obvious ease with which photography can achieve photorealism, there has often been emphasis on the celebration of abstract form within the bodyscape. In many such works—by Lucien Clergue, Bill Brandt, and Edward Weston—folds and cusps abound. André Kertész's *Distortions* of 1933 are particularly apposite regarding persistence.

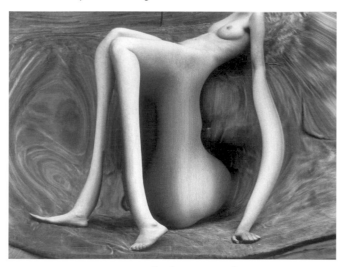

Distortion # 141, Paris, 1933 © Estate of André Kertész/Higher Pictures.

Pepper No. 30 (1930) by Edward Weston.

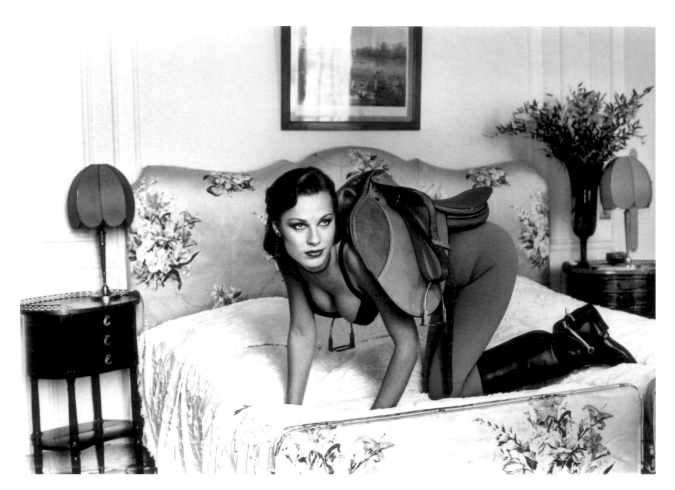

Saddle I, Paris, 1976 © The Helmut Newton Estate / Maconochie Photography.

Helmut Newton's *Saddle 1, Paris (at the Hotel Lancaster)* of 1976 accords with geometry, identifying the human female waist as having a doubly curved saddle morphology.

In sculpture, we could begin with the torsos of classical Greece and Rome, moving through Michelangelo and Bernini, toward Rodin, and find cusps not just on the bodies but on the sumptuously falling folds of cloth-made-stone. We continue to modernism with Henry Moore and Anish Kapoor.

Painters perform the projection step for you, giving you just one 2D view. Sculptors, however, give you the whole 2D-in-3D manifold and allow you to make your own projections. Catastrophe theory is best enjoyed among the real-life marbles and bronzes, rather than delegating the projection to a photographer in some glossy art book. Walk around a sculpture, and you can watch as a swallowtail appears. Walk back, and see it unwind to leave only fold. With practice, you can start to locate the sheets of nothingness that permeate the gallery around the object, the boundaries of Dupin indicatrices heading off to infinity. The catastrophes are on your retina, not on the sculpture, but the sheets of nothingness are there whether the gallery is open or closed.

Again, the cusps persist from classicism to modernism and are easier to find in the latter. Often, that is almost all there is, a fold that crosses in front of another to end sharply but subtly in a cusp. Kapoor's abstract forms are particularly pertinent, as he often seems to boil shapes down to almost pure molecules of form.

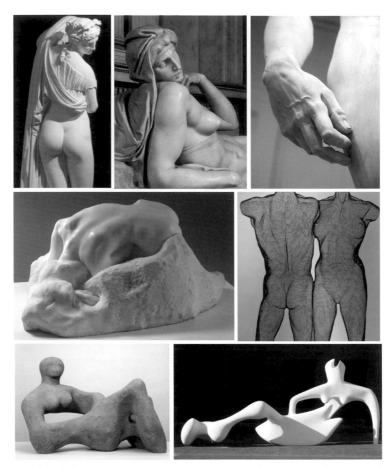

Top left: The *Venus Callipyge. Top middle*: Michelangelo Buonarroti (1475 -1564). *Aurora*. Detail from the Tomb of Lorenzo Medici, Duke of Urbino. Post cleaning. Medici Chapels (New Sacristy) © Scala / Art Resource, NY. *Top right*: Detail of Michelangelo's *David. Center left*: *Danaid*, 1889, Rodin. *Center right*: *Venii II On Blue*, 2005, David Begbie. *Bottom left*: *Recumbent Figure*, 1938, Green Hornton stone, Henry Moore. *Bottom right*: *Large Reclining Figure*, 1984, bronze, Henry Moore.

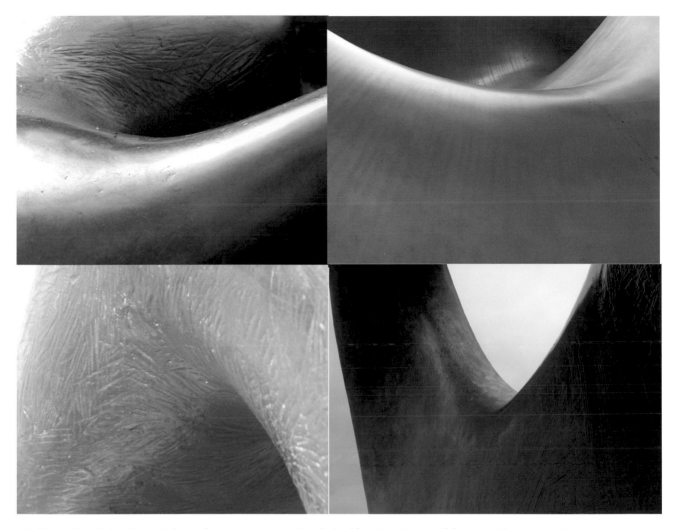

Top left: detail from *Reclining Figure: Angles*, 1979, bronze, Henry Moore. *Top right*: detail from *Large Figure in a Shelter*, 1985–86, bronze, Henry Moore. *Bottom left*: detail from *Three Piece Reclining Figure: Draped*, 1975, bronze, Henry Moore. *Bottom right*: detail from *Double Oval*, 1966, bronze, Henry Moore.

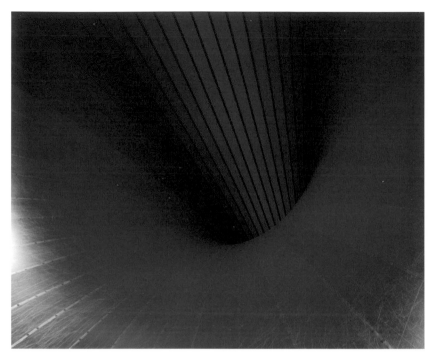
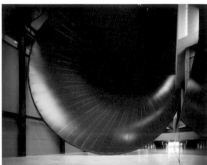

Detail from *The Unilever Series: Marsyas*, 2002–3, Anish Kapoor (1954–). Photo © Anish Kapoor. All Rights Reserved, DACS, London/ ARS, NY 2016.

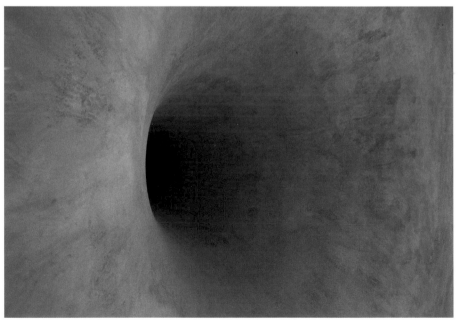

Detail from *Untitled*, Anish Kapoor, 1996 (Malmo Konsthall 1996/1997). Photo: Gerry Johansson © Anish Kapoor. All Rights Reserved, DACS, London/ ARS, NY 2016. Courtesy of Gerry Johansson.

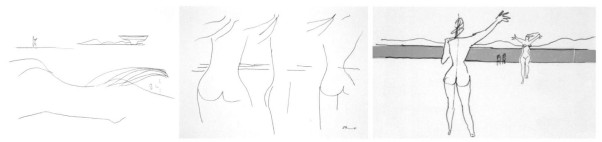

Left: Oscar Niemeyer, "Untitled (Girl lying down/Niteroi)." *Middle*: Oscar Niemeyer, "Untitled (Four females on beach)." *Right*: Oscar Niemeyer, "Untitled (Two figures against horizon)." Images © 2016 Artists Rights Society (ARS), New York / AUTVIS, São Paulo.

Architecture is sculpture on the grand scale, and Gaudi was one of the first to reject the rectilinear, this latter epitomized by the Parthenon in Athens or Le Petit Trianon in the gardens of Versailles, whose rectangles, for reasons that escape me, are much vaunted for their beauty.

Circa 1950, Le Corbusier, arguably the most famous of all architects, wrote *The Poem of the Right Angle*, stemming from the importance he attached to the observation that man stands vertical against the horizon. Several decades later this was countered by Oscar Niemeyer's *Poem of the Curve*, which opens his autobiography, *The Curves of Time*.

> I am not attracted to straight angles or to the straight line, hard and inflexible, created by man.
>
> I am attracted to free-flowing, sensual curves. The curves that I find in the mountains of my country, in the sinuousness of its rivers, in the waves of the ocean, and on the body of the beloved woman.
>
> Curves make up the entire Universe, the curved Universe of Einstein.[21]

The straight-talking Niemeyer calls it as it is—curves are natural, curves are sexy. The book contains many of his sketches, simple but exuberant line drawings of women on the beaches of Rio, their curves and cusps in front of those of the hills behind, all echoed by Niemeyer's futuristic architecture.

Without playing too heavily on stereotypes about hot-blooded Latinos and hard-headed Teutonics, it is interesting to see the German structural engineer Frei Otto arrive at very similar results but via more sober and technical considerations.

Otto designed curvy tension structures and gridshells such as the roofs for the Munich Olympics and the Mannheim Multihalle. For Otto, these have the twin aesthetics of visual elegance and structural efficiency. Tension structures are predominantly hyperbolic, and they carry tensions in the directions of opposing curvature that pull stiffness into the system. And because they are under tension they do not buckle, and so they can span great distances while being less than a millimeter thick.

Frei Otto, Montreal Expo 67 Bau Netz.

Works by Frei Otto. *Top left*:
Mannheim Multihalle Bau
Belastungsversuche.
Top middle: Montreal.
Top right: Viele Zelte Christine
Otto Kanstinger.
Center: Hamburg St. Nikolai.
Bottom: Gypsum model of
pneumatic structure.

And his proposals for pneumatic structures produced results that share much with Lucien Clergue's supine nudes on the beaches of the Riviera.

Deviation from the rectilinear was taken further forward by others who doubtless hate but perhaps deserve their title as blobitects, a group that includes Will Alsop, Future Systems, and Zaha Hadid.[22] Future Systems describes their Birmingham Selfridges thus: "The fluidity of shape recalls the fall of fabric or the soft lines of a body, rises from the ground and gently billows outwards before being drawn in at a kind of waistline." It is a celebration of the power of the curved form to put cusps on retinas, triggering sensuous resonances in the minds of observers.

Haesley Nine Bridges Golf Club House—Korea, 2010, Shigeru Ban Architects (Partnership with KACI International).

Birmingham Selfridges by Future Systems.

London Aquatics Centre, by Zaha Hadid Architects. Photo by Ron Ellis / Shutterstock.com.

Heydar Aliyev Center in Baku, Azerbaijan on May 1, 2015.

Portrait of an Artist (Pool with two figures), 1972 © David Hockney, Art Gallery of New South Wales / Jenni Carter.

Another artist who must be mentioned in our whirlwind survey of catastrophes in art is David Hockney—for his swimming pool paintings. The catastrophic patterns on the floor and the reflections from the water surface clearly inter-est him. At first sight, the bright triple junctions on the floor in *Portrait of an Artist (Pool with two figures)* from 1972 may appear to contravene Thom's grammar of shape, but the more detailed diagram shows two of the possible morphologies.

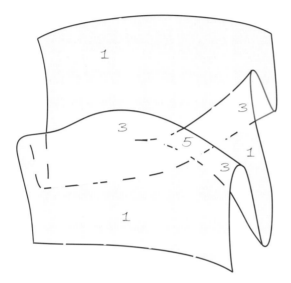

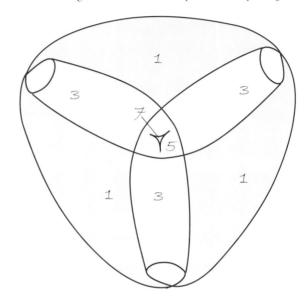

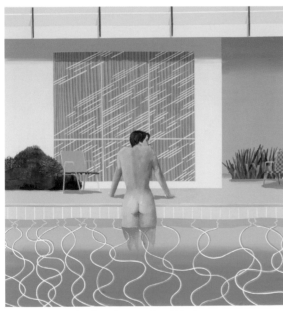

Peter Getting Out of Nick's Pool, 1966 © David Hockney.
Photo Credit: Richard Schmidt Collection Walker Art Gallery, Liverpool.

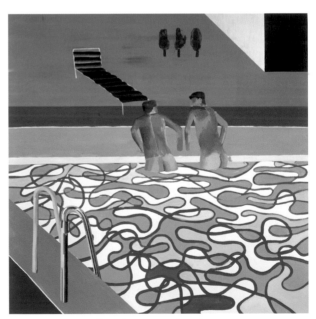

Two Boys in the Pool, Hollywood, 1965 © David Hockney.
Photo Credit: Art Gallery of New South Wales / Jenni Carter.

Painting, sculpture, photography, and architecture all existed long before Thom wrote down his equations, and so the artists are not consciously using his alphabet. But just as many a jazz-improvising autodidact knows what patterns sound good without having studied the weighty textbooks necessary to pass the numerous examinations on music theory, so sculptors create shapes intended to evoke and provoke, and though they may not know it, these shapes have a language. Henry Moore did not set out to demonstrate Thom's alphabet, nor did Anish Kapoor and Zaha Hadid. The fact that their works are rich in catastrophic structure arises simply because they make organic blobs with smoothly curved surfaces. In this respect, our final artist, Naum Gabo, is different. Gabo really has noticed the cusps, and he finds them interesting. Although he may not have had a name for them, he places them knowingly central in most of his major works.

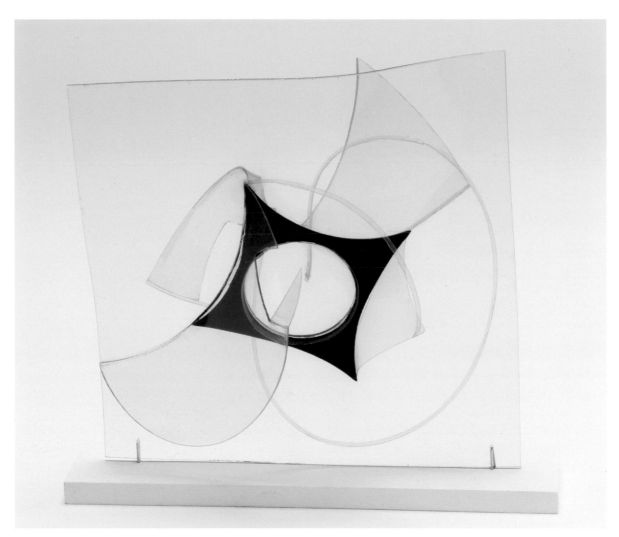

Model for Construction through a Plane, 1935 -37, Naum Gabo (1890–1977).

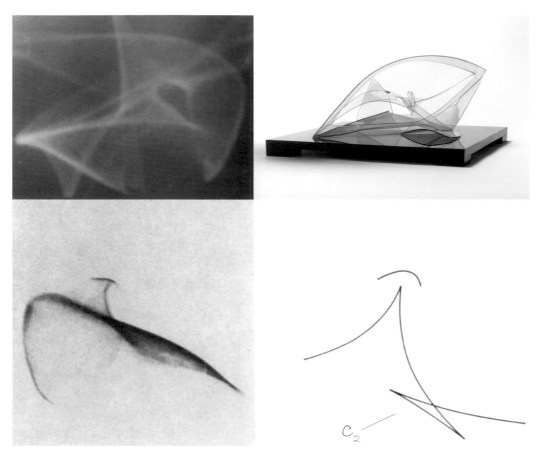

Top left: *Photograph of Reflected Light Pattern*, 1941, Naum Gabo (1890–1977). *Top right*: *Spiral Theme*, 1941, Naum Gabo (1890–1977).
Bottom: Photograph and line drawing from *Structural Stability and Morphogenesis: An Outline of a General Theory of Models* by René Thom.

Gabo studied physics and medicine at Munich University around 1910, and although he was not a particularly distinguished student, his studies did instill an interest in mathematics. He would later visit the Institut Henri Poincaré in Paris and the Science Museum in London. In both places he saw models of mathematical surfaces and took the images away with him to re-create in sculptural form. (Henri Poincaré, incidentally, was one of the early founders of singularity theory.)

Gabo, like Thom, read D'Arcy Thompson's *On Growth and Form*, with its emphasis on the organic shapes found in nature. Gabo, like Thom, looked at—and photographed—the patterns created by light shining through irregular drops of water. In their separate worlds the artist and the mathematician each responded to the same stimuli. Above, the upper-left photograph is by Gabo, the lower left by Thom. Thom provides a line diagram of the catastrophe structure—a nearby hyperbolic umbilic and a swallowtail (quite difficult to discern given the quality of the original image). Gabo's photograph is considerably richer in structure, the bright V shape center left being a rather dramatic hyperbolic umbilic, connected to many clear folds and cusps to its right. Gabo's response is to create the Perspex and celluloid sculpture *Spiral Theme* (1941), top right.

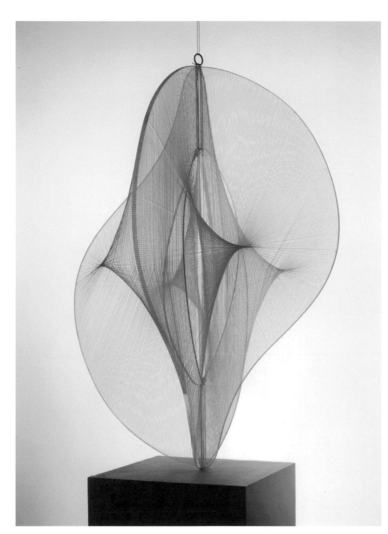

Linear Construction No. 2, 1970-71,
Naum Gabo (1890–1977).

Gabo's *Linear Construction in Space, No. 2*, above, has a skeleton of flat Perspex sheets with curved edges strung with straight nylon strings. It is instantly recognizable as a higher-dimensional precursor of the 2D pin-and-string models that were popular in craft shops in the 1970s, whereby the envelope of a set of straight lines could create attractive curves. Instantly recognizable within the strings are folds meeting at cusps. These cusps do not exist on the sculpture itself but only in the perception of it, the projection onto the retina, in this case via the photographic plate. Gabo clearly found these shapes attractive. It suggests he has seen an astroid, per-

haps on a restaurant tablecloth, and has been enchanted by it. His first *Linear Construction* was made in 1949, while Thom was doing his PhD. His final version was made in 1971, by which time Thom had essentially completed catastrophe theory. Sadly, Thom and Gabo never met.

Geometrically, the models are ruled surfaces, made up of straight lines of string, and this echoes the straightness of the rays of light in geometric optics. The stringy surfaces can pass through each other and, like light, are therefore not restricted to producing only the cuspoid catastrophes and other visual events.

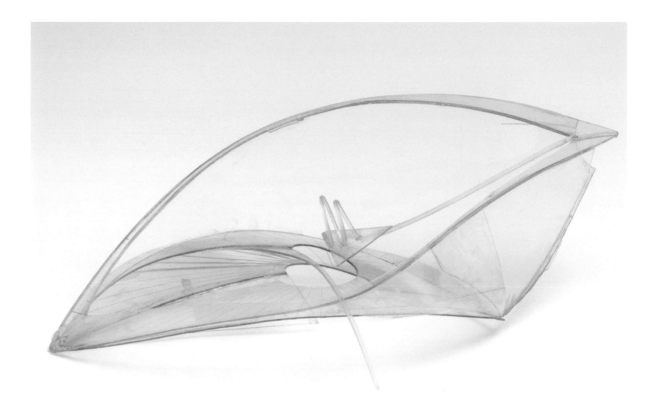

Model for "Spiral Theme," 1941, Naum Gabo (1890–1977).

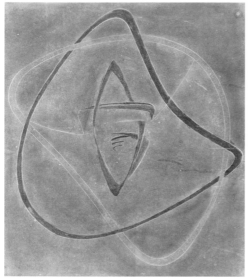

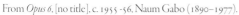

From *Opus 6*, [no title], c. 1955 -56, Naum Gabo (1890–1977).

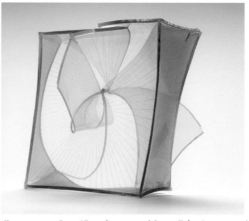

Construction in Space (Crystal), 1937 -39, Naum Gabo (1890–1977).

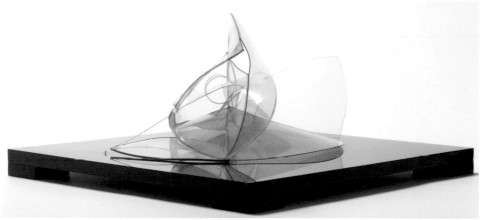

Spiral Theme, 1941, Naum Gabo (1890–1977).

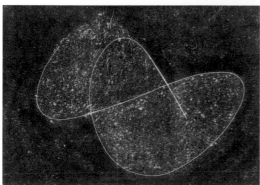

Opus 9, 1973, Naum Gabo (1890–1977).

On the next page are assembled a set of images of an un-folded, four-cusped astroid as it may appear in various forms across the sciences. Below these are two works by Gabo—a woodcut and a Perspex-and-string model. It is clear that Gabo is not just making arbitrary abstract shapes—he is making astroids.

A few years ago I was honored to be invited to submit a piece to a Science-Engineering-Mathematics-Art exhibition

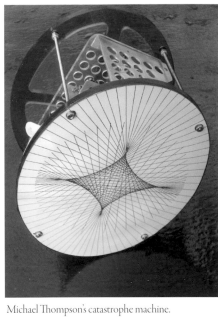

Michael Thompson's catastrophe machine.

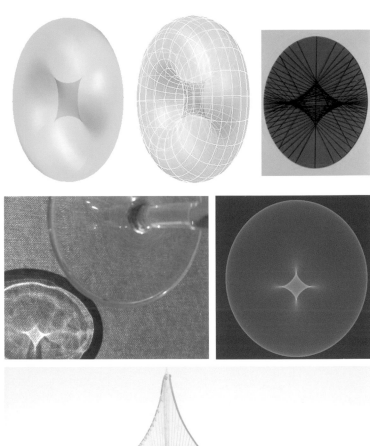

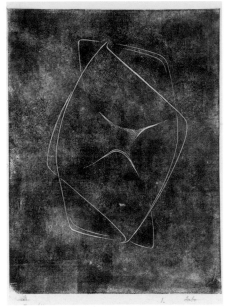

From *Opus 2*, 1950, Naum Gabo (1890–1977).

Linear Construction in Space No 2, 1972 -73, Naum Gabo (1890–1977).

at Kettle's Yard in Cambridge. Kettle's Yard is a small but highly prestigious gallery, formerly the home of Jim Ede, a curator at the Tate, who had close connections to the St. Ives School in Cornwall. The highly influential St. Ives School was established in 1938 by the painter Ben Nicholson and the sculptor Barbara Hepworth; they were later joined by Gabo and then by many others. Kettle's Yard therefore possesses a good number of Nicholsons and Hepworths, along with works by Henry Moore, Brancusi, Gaudier-Brzeska, and other contemporaries. It also has two very nice, albeit small, Gabo string sculptures.

As I had been invited wearing my "engineer's hat," I decided to make a piece that would make visible the mathematics that underlies my engineering stability lectures and yet would acknowledge its resonances with its rather hallowed setting. The idea was to make an optical catastrophe machine that would slow down the patterns-on-the-side-of-boats so that their morphologies could be more keenly observed.

My machine consisted of a flat piece of Perspex to which was loosely affixed some mirrored foil that is used in my laboratory for various aerospace constructions. A pair of small motors, hidden in the pedestal, very slowly moved alternate corners of the Perspex at different frequencies, such that the Perspex flexed almost imperceptibly. This caused small ripples to form in the foil, which slowly evolved with the flexing. The sheet was then illuminated by a bright LED, with the very pleasing result that remarkable patterns of catastrophes appeared on the wall adjacent to the machine. The whole thing was then put inside a darkened enclosure.

I figured that this was a 5D piece, as it had the 4D manifold implicit in geometric optics coupled with the added dimension of time.

I called it *Nonlinear Construction in Space: Homage to René Thom and Naum Gabo*. I know it sounds a bit pompous but the sentiments were sincere. I then observed viewers as they, in turn, observed it. Not only did they enjoy watching the strange, ethereal patterns slowly morph, twist, and flicker on the wall, but none of them could see how the effect was

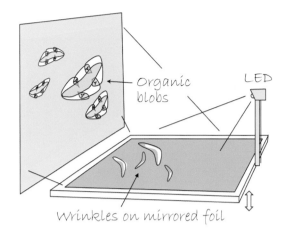

achieved, the flexing and rippling of the sheet and foil being imperceptible unless known about.

My hippie friends, in particular, loved it, to such an extent that I started a patent application, figuring that whoever invented the lava lamp was no doubt very rich by now, and that this was even better. Every bedroom should have one, so you can watch these soothing patterns evolve on your ceiling in the soulful restfulness before sleep.

Sadly a book can only display static images, and so to enjoy the full 5D effect you will have to make your own. You are free to do so, as I never got around to completing the patent application. I like to think that Gabo would have enjoyed these shapes.

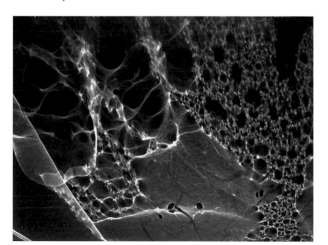

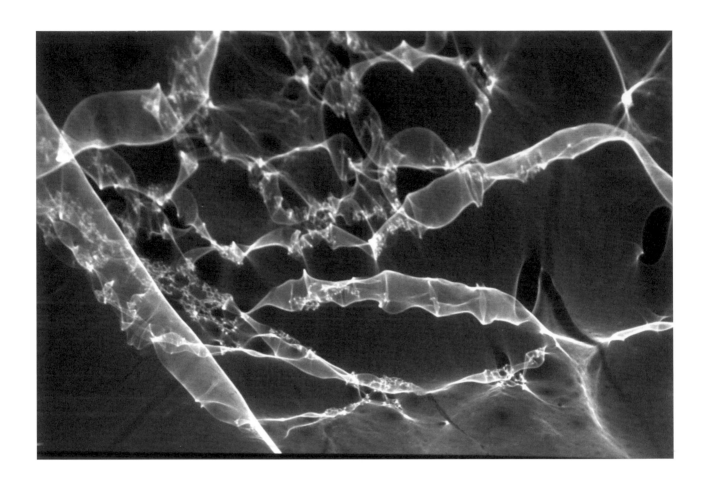

The Pregnance of Curves

Invariance in Gestalt psychology (S. Lehar).

In the early twentieth century, in Berlin, a group of psychologists addressed themselves to the question of perception. With drawing, we go from a 3D body down to a flat 2D representation of it. Members of the Gestalt school, however, were interested in the inverse process: presented with a 2D drawing, how do we construct a mental image of the real 3D object that it represents? It is called *reification*, and it is the opposite of our 3D-to-2D *projection* step. The problem is that 3D-to-2D is unique—there is only one answer. But given a 2D drawing there are infinite possibilities of what it might be the projection of. They performed experiments, showing their subjects lots of line drawings and asking them what they were of. Thom considers this research sufficiently significant that he mentions it on page 1 of *Structural Stability and Morphogenesis*, particularly applauding the "geometric framework" in which they posed the problem.

The Gestalt researchers developed a set of principles—such as proximity, order, regularity, simplicity, invariance, and symmetry—to describe how we find meaning in patterns. They called these principles the Law of Prägnanz.

It would be interesting to repeat those experiments, not with cuboids and spheres but with irregular blobs, to see just how naturally adept we are at recognizing the elements of Thom's alphabet, even without having had the benefit of a course in catastrophe theory.

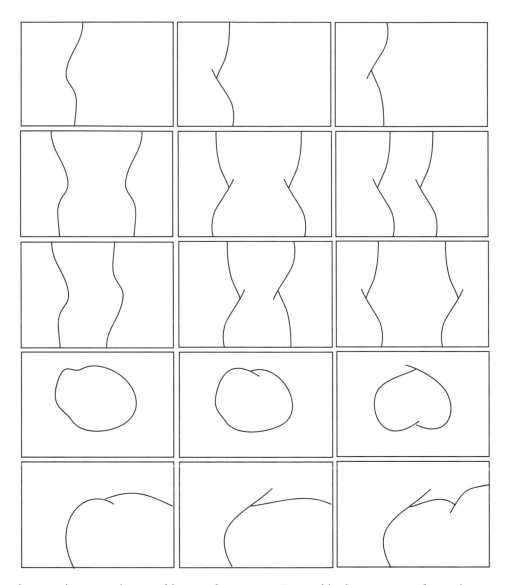

The line diagrams above are indicative of the sort of test possible. These have been constructed with a minimal palette of curves. Some, to my own eye, are unambiguous whereas others are either ambiguous or almost nonsensical.

The unadorned curves are open to ambiguity as to which side the body is on, or indeed, as to whether there even is a body. Perhaps it is just a line. However, the hanging end of an outline, a half cusp of a post-swallowtail pair, removes that ambiguity: there is a body and it is on the cusped side of the line.

Some of the diagrams are confusing: there are cusps on either side of the outline, the grammar of shape is wrong for it to be a simple outline of a body or shape. Perhaps one of the lines is a hair, or a stalk.

Far more interesting than performing dry experiments of this form on a wider range of lines and people in order to extend the Gestalt laws to the perception of curved objects would be to unpack the deeper emotional content of these lines. Despite their rudimentary nature, some of the dia-

Martin Woodhouse, *Untitled*. I saw this picture on a colleague's wall and was immediately struck by how the artist was playfully disrupting our perceptions with outlines that break the laws that we innately recognize. The outlines of the islands, for example, should not extend into the sky.

grams are rather suggestive, not just of a curved surface but of a naked human body. The cusped lines seem to carry far more than just topological information.

Thom's 1988 book *Semiophysics* went well beyond the original mathematics of catastrophe theory. It considered non-smooth systems, where things could appear suddenly out of nothing. The sound of a bell suddenly ringing out against a silent background is not created at a fold catastrophe—it does not need an anti-bell to be co-created.

Semiophysics largely addresses the question of "animal organization," and it extends Thom's original ideas on morphogenesis. It begins with two concepts: *salience* and *pregnance*, the latter clearly name-checking the Gestalt influence.

Salience refers to anything that is "clearly separate from the continuous background against which it stands out," such as the sudden tinkling of a bell in a quiet room.[23]

Pregnance denotes events and shapes that are more than just salient; they are biologically significant, such as

> prey for the (hungry) predator, of the predator for its prey, of a sexual partner at the appropriate time. The recognition of these forms gives rise to a very ample reaction in the sub-

ject: the freeing of hormones, emotive excitement, and behaviour designed to attract or repulse the inductive form.[24]

It seems clear that many of the simple line drawings on the previous page have biological significance and possess what Thom calls "pregnance," and many avenues of ideas cascade immediately from this.

First, if these shapes hold biological significance then there must be an associated genetic basis. Nobel Prize–winning experiments by Niko Tinbergen and Konrad Lorenz showed that newly hatched gull chicks pecked preferentially at lollipop sticks painted to resemble a mother gull's beak, newborn sticklebacks reacted vigorously to shapes of the appropriate color—including even to passing mail vans—and newborn goslings would run faster when a piece of cardboard held above them was hawk-shaped. The genome thus contains not just the instructions for constructing cerebral hardware preloaded with pattern recognition software but also information about which patterns and colors are significant. It is no great stretch from there to having the human genome being preloaded with information about visual recognition of human body shapes. The line diagrams tap into that spring, via which visual stimuli can lead to deeper inner stirrings.

Second, although there is an obvious genetic advantage in being able to rapidly recognize a potential mate, it does not fully account for why humans have ended up with the body shapes they have. Much has been written on this subject, often based on psychology experiments involving the sexual preferences of American university students. The mechanism of *sex selection*—as opposed to the more usual mechanism of survival of the fittest—is evident in biological extravagances such as the peacock's tail and the courtship dances of bower birds and sage grouse. One sex has genes that allow them to recognize and to prefer mates possessing particular bodily characteristics. The other sex has genes for creating such characteristics. There is thus a feedback loop and the genes co-evolve to reinforce each other. This, simply, is the origin of the seduction of curves. We prefer curves

because our mates' bodies are curved. Our mates' bodies are curved because we prefer curves. Our intuitive ability to extract significant information from curves, and to have deeply-lying responses to them, is the product of genetics.

The sex selection feedback loop does not need to have an evolutionary advantage; it can—like the peacock's tail—be almost arbitrary. Our own feedback loops need not have ended in our smooth, curved bodies. We could, almost equally likely, have ended up with hedgehog spikes. Had we done so, I would then be writing a book about spikes and why we find them so beautiful.

One small strand of beauty thus has a Darwinian origin, but—with few notable exceptions—the theory of art has largely ignored or shunned this. In *Art and Illusion*, the doyen of art theorists E. H. Gombrich wrote:

> Now, I do not believe that the mystery of Raphael will one day be solved through the study of gulls. My sympathies are with all those who warn us against rash speculations about inborn reactions in man—whether they come from the racialist camp or that of Jung. The dignity of man, as Pico della Mirandola felt, lies precisely in his Protean capacity for change.[25]

Gombrich dismisses the science of Lorenz and Tinbergen using Mirandola's *Oration on the Dignity of Man*, a Renaissance text of 1486 that describes a conversation between God and Adam. And Gombrich's choice of Raphael as the hallowed exemplar of high art is ironic indeed. He may have had the name of an archangel, but he had very human and very fleshy sexual proclivities.

The nub of Gombrich's argument is Mirandola's imagined dialogue in which God grants free will to Adam, telling him that "you may, as the free and proud shaper of your own being, fashion yourself in the form you may prefer."[26]

It is an odd basis on which to reject the notion of innate preferences, not only in the face of the experiments of Tinbergen and Lorenz but in the face of daily evidence to the contrary. We each have our own sexual preferences. Raphael preferred women, and Michelangelo men. We did not "fashion" those preferences ourselves.

In *Lives of the Most Excellent Painters, Sculptors and Architects*, written a few decades after Raphael's premature death in 1520, Vasari describes how Raphael neglected his commission to paint the Chigi Palace and would only complete it when his friends managed to install his mistress there. Vasari concludes:

> Raphael continued his secret pleasures beyond all measure. After an unusually wild debauch he returned home with a severe fever, and the doctors believed him to have caught a chill. As he did not confess the cause of his disorder, the doctors imprudently let blood, thus enfeebling him when he needed restoratives.[27]

Thus died Raphael in a sea of bodily fluids from a combination of sex and medieval medicine. And yet art theorists like Gombrich have made their heroes into gods and have guarded their professional turf by saying it is all too exquisitely profound for dull scientists to have anything of value to add.

How much more refreshing to hear Kenneth Clark, on Michelangelo's *Night* in the Medici Chapel of the Basilica of San Lorenzo in Florence, with its preposterous pastiche of a male body adorned with ice-cream-scoop breasts:

> We know, from a quantity of evidence, that Michelangelo considered the female body inferior to the male … this was the period of his life when he was most troubled by his erotic feelings for young men, … he may not have trusted himself to include in the chapel a male embodiment of softness and grace …

and

> The breasts, for example, which from the 5th century onwards had been intermediaries between geometry and the senses … are reduced, in the *Night*, to humiliating appendages.[28]

Sex did not arrive in art with Koons, Emin, or Gilbert and George, or even with Schiele and Klimt. It has been there since the Renaissance, and even before. However, its influence has been willfully ignored by some who have tried to elevate art into something preternatural. And even given the preponderance of recent egregious examples, the role of sex—and thus of genetics—in art has still not been properly unraveled.

Let us return to Nick Guest's bedroom in *The Line of Beauty* where he is bemoaning Hogarth's choice of inanimate objects by which to illustrate the *Analysis*. At his time of writing, Hogarth lacked at least two key elements that are now available to us: he did not have the benefit of Darwin to explain our innate attraction for the curves of the body, and he did not have Thom to explain why a piece of bent wire has the wrong topology with which to evoke a body form. Perhaps if Hogarth were writing today, the *Analysis* would be replete with post-swallowtail cusps on waists that would better please the postcoital Nick.

Art theory, with its penchant for the mythic, took an extraordinary wrong turn in the eighteenth century. It all stems from Hogarth's bent wire and the subsequent identification of the bent wire with the serpent from the Book of Genesis, the Genesis of Gombrich and of Mirandola. There is the Serpentine school, the landscape architects of eighteenth-century England—William Kent, Humphry Repton, and Capability Brown—who created Gardens of Eden in this green and pleasant land with rivulets winding through naturally curving hillsides. It was a rejection of the Euclidean geometry, the cuboid topiary, and the rectilinear parterres of the Dutch and French styles, as exemplified by the manicured gardens of Versailles.

The topological grammar of Hogarth's bent wire—the arch, cusp, loop sequence we saw in earlier photographs—is not the one we carry innately in our genes. Instead we are born to feel attraction for the shapes of the human body. These are the curves that carry pregnance. These are the curves of Thom.

In 1730, Queen Caroline decided against a rectangular lake in the middle of Hyde Park. Instead she chose to let the lake follow the undulations of the land, letting it flood the natural courses of the River Westbourne and Tyburn Brook. The lake is called the Serpentine, and it is the wrong name. The English park and the English garden have a long association with the mythology of Eden. The giant botanical theme park in Cornwall with its Buckminster Fuller domes is the Eden Project. And if the English garden is the Garden of Eden, then even though Michelangelo may revel in the voluptuous curves of Adam's body, the art theorists still somehow latched onto the wretched snake.

The threads of creation, downfall, and beauty are all there in the Book of Genesis. There is the creation of the cosmos, the Earth, and mankind. There is the Fall from Grace and there is the paradise of Eden, an island of Beauty surrounded by the inhospitable wastelands of the Sublime.

The Serpentine in Hyde Park, London, is a piece of art theory visible from space. A curving lake created by Queen Caroline as a rejection of the rectilinear and in embrace of more natural organic forms, it is badly named—after a snake.

Toward the conclusion of Hollinghurst's *Line of Beauty*, Nick Guest wanders across Hyde Park, noticing the doubly curved ogee form of the bandstand roof and the "huge-thighed horseman" atop Watts's monument "to, or of"[29] Physical Energy. And yet despite his highly attuned aesthetic sensibilities and stylistic alertness, Nick somehow manages not to notice the lake and all its pregnance, even as he walks alongside it. With extraordinary restraint, Hollinghurst makes no mention of one of the few pieces of art theory visible from space—a lake fashioned in the style of the Line of Beauty.

At a book reading, I once asked Alan Hollinghurst why he had chosen not to mention the lake in this scene. He was pleased that I had noticed its omission but replied that "it would have been too obvious." Actually, the word he used was not obvious, it was "quishy."

Each year the Serpentine Gallery in Hyde Park commissions a leading architect to design a summer pavilion there. Oscar Niemeyer has been one such, and Zaha Hadid has since made a curvaceous Sackler Gallery there. However, I am not aware that any of these have been created in knowing reference to the location, its significance in art history, and its relationship to the Book of Genesis and the bodies of Adam and Eve. Perhaps, like Alan Hollinghurst, they all thought that would have been too quishy.

The Serpentine Sackler Gallery, Hyde Park, London, by Zaha Hadid Architects.

There is no single Line of Beauty. It is not a bent wire, and it has nothing to do with snakes. The Lines of Beauty are the outlines formed on our retinas when we observe the human body. The geometry of the senses is etched in the Book of Genes.

This is the Seduction of Curves.

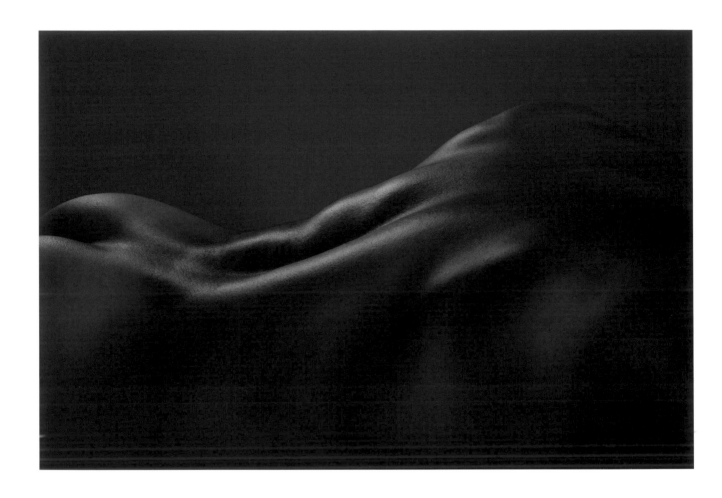

Thom

Born in 1923 in a small French town near the Swiss border, René Thom grew to become a giant of mathematics—and a cultural icon sufficiently "cool" that he was once the subject of a fifty-three-minute film by Jean-Luc Godard.[30]

If this book has succeeded in explaining some parts of catastrophe theory, there is a danger it may suggest that Thom's mathematics is not particularly difficult. However, learning the do-re-mi of catastrophes is a long way from being able to appreciate the concerto that was his doctoral thesis, "Fibre Spaces in Spheres and Steenrod Squares,"[31] the work that won him the Fields Medal. Even though the medal citation spoke of the "great simplicity" of his work, it is—to most people—far from anything such.

Likewise, the "pantalons" diagram that Thom often used to explain his early work on "cobordism"—the mathematics of how lower-dimensional objects can be connected by forming the boundaries of a higher-dimensional object—gives the misleading impression that it is all rather easy. The pantalons are simply a way of smoothly connecting the two smaller circles at the base with the one larger circle at the top. That much is easy, but it soon becomes extremely difficult. Can you create some higher-dimensional pantalons that connect two Klein bottles to a sphere?

A pantalons diagram.

Although Thom is most widely known for catastrophe theory, his mathematical reach was considerably deeper. There is a Thom space, a Thom isomorphism, a Thom class, the Thom Transversality Theorem, the Dold-Thom Theorem, the Thom-Porteous Formula, and the Thom Conjecture (only proved in 1994).

Théorème III.10. *Dans toute variété orientable différentiable compacte V^n, les homomorphismes $Q_p^i : H^{n-i}(V^n ; Z_p) \to H^n (V^n ; Z_p)$ sont nuls (p, i impaires).*
 Par exemple: $Q_3^5 = St_3^4 St_3^1 : H^{n-5}(V^n) \to H^n(V^n ; Z_3)$ est nul.[32]

In the years after Thom received the Fields Medal, his investigations went far beyond the austere purity of mainstream topology, as he pursued his interests into the origins of biological morphogenesis, linguistics, and epistemology. His 2002 obituary in *The Guardian* suggests that this willingness to be diverted away from pure mathematics was not solely due to the fact that he had an inquiring mind with broad-ranging interests. Rather, it suggests that Thom did not even consider himself to be the best topologist in his building. Alexandre Grothendieck, also at the Institut des Hautes Études Scientifiques (IHES) just south of Paris, was by then making sweeping inroads into the fields of algebraic geometry and beyond. Loosely speaking, there seemed little point in doing mathematics next to Grothendieck.

Whatever the cause, Thom—having entered the fields beyond pure mathematics—proceeded without boundary. One could say he took a left turn and he just kept going.

First circulating in draft form in Paris in 1968 (of all years), and translated into English in 1975, *Structural Stability and Morphogenesis* not only lays out the mathematical basis of catastrophe theory but has an extraordinary range of subject matter. It doesn't just cover biological morphogenesis and embryology but has a final chapter titled "Thought and Language," addressing topics as diverse as sexuality, dreams, play, language, art, the military society, and money. Such excursions beyond the mainstream were bound to raise eyebrows.

Criticism mounted when the English mathematician Christopher Zeeman took catastrophe theory into woollier areas of the social sciences, most notably with papers about cusp catastrophes underlying prison riots, the outbreak of war, and the fight-or-flight behavior of angry dogs.

The first criticisms, in papers by Zahler and Sussmann, were not aimed at the mathematics but at the way that it was being applied in the social and biological sciences.[33]

Things became considerably more heated in 1977, when the *American Mathematical Society* published Stephen Smale's review of the anthology of Zeeman's collected papers.[34] Smale attacked not only Zeeman's but also Thom's approach to problems outside mathematics. Much sting came from

the fact that Smale was a world-class mathematician who had shown how to turn a sphere inside out without creasing it and—on the beaches of Rio—had proved a version of the Poincaré conjecture[35] in five or more dimensions, all of which had won him the Fields Medal. Furthermore, Smale had been a frequent visitor of Thom's at the IHES in Paris, and Smale saw catastrophe theory as merely the starting point for a larger, deeper picture—that of dynamical systems theory (commonly known as chaos theory), of which Smale was a leading exponent.

The great Russian singularity theorist Vladimir Arnol'd devoted a chapter of his book *Catastrophe Theory* to "the mysticism of catastrophe theory." It says Thom engaged in "a broad propaganda for catastrophe theory," and it damns with faint praise by stating that Thom merely recognized "the all-encompassing nature of Whitney's work." And "to enable the reader to form his own impression," Arnol'd presents an outlandish example of Thom's philosophical writing style, a passage that touches on Freud, Poseidon, and Athena.[36]

For all his undoubted brilliance, Thom brought much of this criticism on himself. To state that "biology is nothing other than an immense cemetery of facts" is bound to alienate scientists, all of whom recognize the centrality of the experimental method.

Although the criticisms from Smale and Arnol'd would have hurt, Thom persisted, publishing several books over the coming decades—most notably *Semiophysics*—in much the same vein, a mixture of mathematics and speculations about applications in science (particularly embryology) and that then headed much further afield, taking in epistemology and the theory of language. *Semiophysics* even has a subchapter on house building.

At the 1971 Symposium on Dynamical Systems in Bahia, Brazil, Thom presented a highly philosophical paper in which he sought to reinterpret the whole field of formal linguistics in terms of geometry and topology, almost without reference to any previous work in the area. This heavily philosophical approach, with writing that was highly obscure and often ambiguous, soon brought Thom to the attention of the postmodernist philosophers. A leading postmodernist, Jean-Francois Lyotard, hailed catastrophe theory as an exemplar of "postmodern science."

The issue at the heart of the attacks by his fellow mathematicians was what Thom called, rather archly, "The Two-Fold Way." It refers to the two different manners—the *physical* and the *metaphysical*—in which catastrophe theory could be applied to science. There is a longstanding demarcation in science between the Galilean and the Aristotelian, Galileo being aligned with experiments and Aristotle with pure thought. Thom's demarcation is similar, but since it concerns mathematics, the argument is already skewed toward thought.

Thom's "physical" is the standard approach: sets of equations are constructed from the underlying physical laws (the laws of mechanics, say), and these are then solved and compared with experiments. Catastrophe theory is only added later, to describe how all the possible solutions are organized.

The "metaphysical" approach is Thom's own: given something you do not understand, start with catastrophe theory and develop the model from there. We have already seen this in Thom's approach to the genitals—there are certain symmetries and symmetry-breakings—and the simplest catastrophe that possesses these is the parabolic umbilic, so that catastrophe—according to Thom—is the basis of the simplest model. The approach is highly Aristotelian. *Semiophysics* even has the subtitle "Aristotelian Physics and Catastrophe Theory."

The spectacular progress of science since the Enlightenment is largely built on the Galilean approach, as embodied by "the scientific method"—observe the Universe, form testable hypotheses and use these to make predictions, do experiments to test the predictions, and reject hypotheses whose predictions do not agree with the experiments. The hypotheses that remain, although not proven, are then in some sense closer to the truth than those that have been discarded. It is a form of intellectual "survival of the fittest," analogous to Nature's own Darwinian Evolutionary Algorithm of repeated copy-vary-select via which, to use Richard Dawkins's phrase, life has climbed Mount Improbable. Better theories survive. It is evolutionary epistemology, and although philosophers—from Bacon and Hume through to Popper and Kuhn—have split hairs over nuances for centuries, the scientific method stands as something of an unassailable ideological bastion.

Mathematics has long had a highly fruitful partnership with science, but the underlying philosophies differ distinctly. Mathematics inhabits an abstract Platonic nonreality, a world of numbers and patterns where theorems are proved not by doing physical experiments but by pure thought and logic. Theorems are proven, whereas theories are merely "not yet falsified."

Although the power of the scientific method is largely self-evident, there are nuances. Even in a "hard" science like physics, there is an obvious current difficulty with the many beautiful string and brane theories that endeavor to unite general relativity with the Standard Model of particle physics, and yet whose predictions are beyond the realm of anything that is currently testable experimentally. In biology, numerous subtleties and disagreements exist in the areas where the comparatively "harder" sciences of genetics and zoology overlap with their "softer" cousins of anthropology, ethology, evolutionary psychology, behavioral ecology, and gene-culture co-evolution. These were the scientific borderlands that saw the heated debate that followed Edward O. Wilson's 1975 book *Sociobiology*, whose final chapter took observations from the animal kingdom and tentatively extrapolated them to human behavior. All sides of the "Sociobiology debate" are covered in Laland and Brown's *Sense and Nonsense*, with the authors—who have scientific backgrounds—largely concluding that there should be more methodical science and less speculative conjecturing, this latter being the titular Nonsense. Further into the social sciences, the normative strand of economics concerns itself with what ought to be, rather than what is, and thus addresses questions that are already far from access via the scientific method—questions of equality and justice, liberties and rights. As one moves further yet—to philosophy, politics, and even art—the emphases and the rules of debate change further still.

Against such a wider background of the human intellectual landscape, the criticisms of Smale and Arnol'd can be seen to cover only a small corner of the set of possible discourses—those concerning model-making in the sciences. And the choice offered by Thom's Two-Fold Way, physical or metaphysical, only involves one part of that—the step in the scientific method where hypotheses are formed. On that important—but limited—territory most scientists would probably agree with Smale and Arnol'd in siding with the "physical" way of making models, the way that aligns with the more methodical process of traditional science.

But what if Thom has headed off into areas—such as the philosophy of language—where the scientific method has only marginal power? Rather ironically, Zahler and Sussmann's critique against catastrophe theory first appeared in a journal titled *Synthese*, and yet there is no attempt at synthesis, no attempt to assimilate the Two-Fold Way into a larger whole.[37]

The Two-Fold Way is, loosely, "be careful or be cavalier." Conservative scientists are always going to choose the first path, but in the 1970s there were other areas of the French intelligentsia where a maverick disdain for convention was something to be admired. These were the postmodernist philosophers, a predominantly left-wing school that—ironically, given its anti-authoritarian rhetoric—was the ruling ideology in the humanities departments of post-1968 French universities. Many of Thom's wider speculations concerned the theory of language, and the theory of language was central to postmodernism.

Around 1910, the Swiss linguist Ferdinand de Saussure had described language as a series of "signs" consisting of "signified" and "signifier." The "signified" was the concept and the "signifier" was the written or spoken word that signified it. It is hardly rocket science, but it took off, becoming the school of "structuralism." It was picked up by researchers in other sociocultural fields, the list of famous names including the anthropologist Claude Levi-Strauss, the social theorist Michel Foucault, the literary critic Roland Barthes, and the psychoanalyst Jacques Lacan.

By the 1970s, structuralism had been supplanted by poststructuralism, with Jacques Derrida its leading light. The concept of "sign" was extended to almost anything under study, whether a text, a painting, an item of clothing, or an illness. Derrida's phrase "there is nothing outside of the text" became something of a battle cry. There was added emphasis on power, politics, and identity. And ambiguity—the ability of a signifier to correspond to multiple signifieds—was highly prized. It made "meaning" more slippery. And rather than simply studying ambiguity, post-structuralists invariably adopted a writing style that was itself deliberately obscure and ambiguous.

Thom's papers on the theory of language, and his semi-mystical and obscure style of writing, made him attractive to the postmodernists. In one of his typically heavily philosophical books, *Prédire n'est pas expliquer*, Thom describes being invited to a meal with Jacques Lacan.[38]

Lacan was a Freudian psychoanalyst whose philosophical writings contain much on Oedipus, castration, ego, and desire. One of his maxims—"the unconscious is structured like a language"—gives an indication of how Saussure's linguistic theories were then carried across to psychoanalysis, with the illness as the "signified" and the symptom as the "signifier."

Lacan invented "matheme," a symbolic system that was intended to remove ambiguity by adopting a formal mathematical style. However, it perhaps muddied matters further. As an example, here is Lacan on the subject of women:

> That the subject here proposes itself to be called woman depends on two modes. Here they are:
>
> $$\overline{\exists}x \cdot \overline{\Phi x}; \text{ and } \overline{\forall}x \cdot \overline{\Phi x}.$$
>
> Which is to be understood not in the sense that, to reduce our quantors to their reading according to Aristotle, would set the *notexistone* equal to the *noneis* of its negative universal, would make the μή πάντες come back, the *notall* (that he was nevertheless able to formulate), to testify to the existence of a subject to say no to the phallic function …[39]

According to Lacan, "The phallus is the signifier of signifiers, the privileged signifier of that mark in which the role of the logos is joined with the advent of desire."[40]

In 1997, in *Intellectual Impostures*, the mathematical physicists Alan Sokal and Jean Bricmont present this and a litany of other egregious examples where postmodern (and mostly French) philosophers have used mathematical language with

little to no understanding of its meaning. Lacan gets a whole chapter. There is such a wealth of material that Sokal and Bricmont find no space to mention Gilles Deleuze's *The Fold*, a 1988 monograph on Leibniz and the Baroque that is highly regarded in some corners of art and architecture. *The Fold* mentions Thom, but only briefly. I have little idea as to what the sentences mean, even when I understand every word.

Postmodernism is the very antithesis of science and the scientific method. So when Jean-François Lyotard and other postmodernists hailed catastrophe theory as an example of "postmodern science,"[41] coupled with Thom's speculations and writing style, it should not be surprising that other mathematicians and scientists would consider that catastrophe theory has strayed too far from the fold.

Let us return to Lacan. At first glance, his matheme looks very much like the sentences from Thom's thesis, full of mathematical symbols and Greek letters, but with the intervening words "fibre bundle," "Steenrod square," and "homo-morphism" replaced with words like "phallus," "narcissistic tendency," and "woman." To most scientists it is gobbledygook, and Lacan has been accused, rather sweetly, of suffering from "physics envy."

In *Le Sinthome* (The Symptom), circa 1975, Lacan extended his matheme to topology. This was a leap—from writing in borrowed symbols to trying to describe psychoanalytical phenomena in terms of topological spaces and shapes.

He described childhood psychological development in terms of Borromean rings: three rings, no two of which are linked, but if one ring is cut, then all three come apart. It is an elementary item of knot theory.

Lacan labels the three rings as real, imaginary, and symbolic, and he builds from there. The Symptom becomes a fourth ring, threading through the other three. The Borromean rings became the logo for Lacanians around the world.

According to Lacanian topology, the phallus is identified with the "irreducible singularity in the projective plane." I

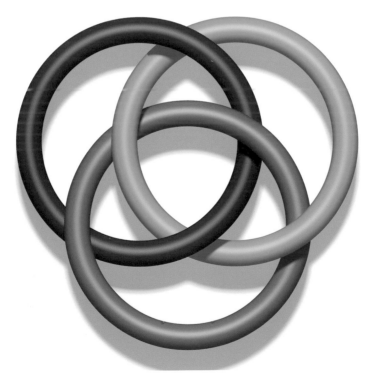

Borromean rings.

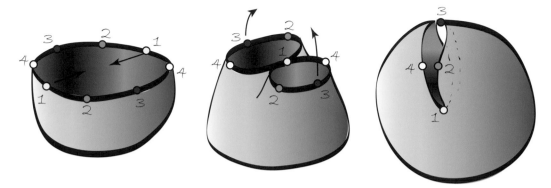

have never quite understood this identification, but I find it intriguing that Lacanians invest so much time in their seminars trying to understand this particular topological shape (the shape of the projective plane, that is). Although it resonates somewhat with Thom's association of genital formation with the parabolic umbilic, Lacan's topological identification is decidedly different.

The "phallus" refers here not to the biological manifestation of the male sex organ but to all the cultural and emotional accoutrements that go with having a penis, ranging from masculinity and fatherhood to patriarchy.

The projective plane is one of the most fundamental objects of topology but is nevertheless rather difficult to visualize. One description is that it is formed by gluing the (single) edge of a Möbius strip around the edge of a circular disk. Another, equivalent description is that it is a disk where diametrically opposite points on the perimeter have been identified. Although this sounds simple, if you actually try to join up the opposing dots, you end up with a rather convoluted shape. Indeed, you cannot actually connect them in 3D space without the surface having to pass through itself.

In a typical construction, like the one above, there are two singularities, one at each end of the line of self-intersection. The upper one here is a Whitney Umbrella, the very object we used to construct the umbilics in an earlier chapter. The lower singularity seems to be the one that Lacan is identifying with the phallus, but this is not altogether clear. And although Lacan refers to it as "the *irreducible* singularity," it is possible to construct a projective plane in 3D with no singularities.

A manifestation of the projective plane in 3D. The singularity at the top of the line of self-intersection is a Whitney Umbrella. Horizontal slices through the upper and lower parts reveal infinity and zero symbols, respectively, a fact of absolutely no significance, other than that it may help you visualize the surface.

In 1901, David Hilbert—a giant of mathematics—asked his student Werner Boy to show that the projective plane could not be immersed into 3D space without singularity. To Hilbert's great surprise, Boy quickly proved instead that it could be. He produced what is now known as *Boy's Surface*, shown below. It still has lines of self-intersection, but there is no singularity.

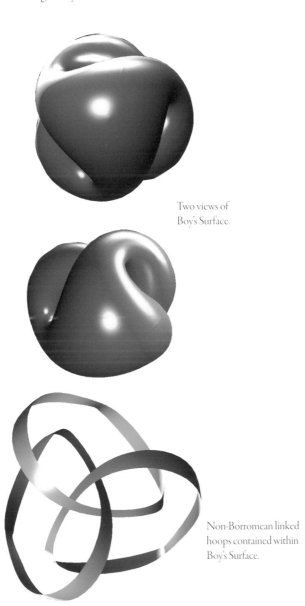

Two views of
Boy's Surface.

Non-Borromean linked
hoops contained within
Boy's Surface.

Let's now return to the meal to which Lacan has invited Thom. Thom describes explaining his mathematics to Lacan, and at the end of the meal, Thom comes out with the rather gnomic statement: "The thing that limits the truth isn't the false, it's the insignificant." Lacan is impressed by this.

In his book, Thom then expands on what he meant by this phrase. He does so via a pastiche of a "carte du Tendre." Originally this was a seventeenth-century map of an imaginary landscape that must be crossed by those seeking love, past the Lake of Indifference and past villages with names like Love Letters and Little Trinkets.

In Thom's version, there is an *x*-axis running from False to True, and a *y*-axis rising from Insignificance to Significance. Bottom center is the Sea of Insignificance, separating truth and falsity. He places Biology at the lower right, true but highly insignificant. Its signifier (if you will) is a rat in a cage, perhaps illuminating Thom's earlier statement about the subject being a "cemetery of facts." Thom is a theorist. If he sees another part of the scientific method requiring experimentalists to undertake the systematic killing of millions of animals in order to falsify hypotheses, then perhaps his phrase reflects some repugnance at this.

Perhaps surprisingly, the Temple of Mathematics is not top right but is placed near the center, only slightly higher than the Fortress of Tautology. Postmodernist literature is on the Lowlands of Ambiguity, largely false and almost completely insignificant.

The highest significance goes to the Massifs of Poetry and of Reality, next to the towering Pic du Paradoxe, beside the surprisingly high Altiplano of the Absurde.

Thom describes the picture as an amusement but says it nevertheless reflects something he believes: the *logos*. It is a word that means "the word" but is loaded with overtones of Heraclitus, Aristotle, Heidegger, and even possibly Lacan. For Aristotle, it meant rational discourse, as opposed to appealing to emotional (*pathos*) or moral (*ethos*) sentiments. Exactly what Thom—or even Aristotle—meant by the term is not, as the postmodernists would rightly have it, for me to say: the text is all there is. The interested reader should thus

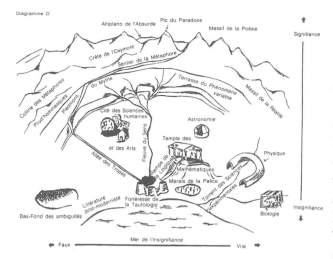

Thom's "Carte du Tendre," from *Prédire n'est pas expliquer* (Paris: Flammarion, 1993). Photo by Hiroyuki Hirai.

consult the texts themselves. However, note that—while "rational discourse" may sound laudable to any scientist—it is loaded with overtones of Thom's Aristotelian approach and its sometimes uneasy relationship with the Galilean experimental basis of the scientific method. And although largely beyond the reach of science, the emotional and moral are equally, if not more, important spheres of humanity—albeit that they are not always a good way to construct a persuasive argument.

In 1980 Thom entered another fray, the argument over the role of indeterminism in science. With a provocatively titled article "Halte au hasard, silence au bruit" (loosely, "Stop chance, silence noise"), he began:

> I'd like to say straight away that this fascination with randomness above all bears witness to an unscientific attitude. It is also to a large degree the result of a certain mental confusion, which is forgivable in authors with a literary training, but hard to excuse in scientists experienced in the rigours of rational inquiry.[42]

The boot, it seemed, was now on the other foot. From being kicked, Thom was kicking, and one of his primary targets was Ilya Prigogine. Prigogine won the 1977 Nobel Prize for Chemistry for his work on non-equilibrium thermody-

namics, later extending his research into the areas of self-organization in complex systems and into the indeterminism inherent in chaos theory. Thom's charges were rebutted vigorously by Prigogine and others.

With distant echoes of Einstein's statement that "God does not play dice with the Universe," Thom's charges were largely along the lines that anyone who had to resort to chance to explain the Universe simply did not understand it well enough. Much of this heated debate was conducted at a symposium held under the dome of the Dalí Theatre-Museum in Figueres, Spain, in 1985, with Prigogine and Thom in attendance, and Salvador Dalí, by then suffering the ravages of age and Parkinson's disease, listening via video link from his bedroom. While it does not fall to me to adjudicate in this matter, the scientific consensus appears to side almost unanimously with Prigogine.

So where does this leave us regarding Thom's relationship with postmodernism on one side and science on the other? Again, it is not my role, nor is it even within my capabilities, to definitively chronicle Thom's relationship with these schools of thought, if indeed there is such a thing as "definitive."

Postmodernism sets itself in opposition to the reigning ideology, challengingly, almost mockingly. Should we just see its exponents as charlatans and sophists, Gaulois-smoking left-wing intellectuals with too much time on their hands, objects to be ridiculed—as Sokal and Bricmont did—from the vaunted bastions of science, while in the background the Scientific Method makes its inexorable Onward March of Progress along the "physical" branch of the Two-Fold Way, largely unperturbed by rabble-rousers?

And do we cast Thom as someone who dabbled on the other side of this divide, someone good at mathematics but prone to taking flights of meaningless fancy while the more sober mathematicians and scientists got quietly on with their steadier endeavors? No, it is more complicated.

Two of the battle cries of postmodernism are that there are no binaries, and there is no Grand Narrative. It would be a rum binary that cast Smale, Arnol'd, Sokal, and Grothend-

ieck as representatives of the Establishment. Stephen Smale was subpoenaed by the House Un-American Activities Committee. And considering it is a mathematics book, Vladimir Arnol'd's *Catastrophe Theory* contains some surprisingly passionate sections berating the stupidity of nuclear weapons. Alan Sokal is an "unabashed Old Leftist" who taught mathematics at the National Autonomous University of Nicaragua during the Sandinista years. And Alexandre Grothendieck—the son of anarchist parents who were involved in the Spanish Civil War, his father later murdered in Auschwitz—has no nationality. He taught category theory in the forests around Hanoi while it was being bombed. He left the IHES over its military funding and turned down the Crafoord Prize, finally leaving mathematics to live in seclusion, possibly somewhere in the Pyrenees, possibly herding goats, from where he wrote, before his death in 2014, that his works should be removed from libraries and destroyed, even though they are texts central to much modern mathematics.

The simple picture that Thom upset the Scientific Establishment by wandering too far outside it does not stand up to scrutiny when so many of his critics were also maverick. And the binary of "science good, postmodernism bad" also misses how many of the most important questions facing the world are those of political power, justice, and ideology that lie beyond the reach of the scientific method and require different modes of discourse.

In 1992, my own institution, Cambridge University, decided to award its highest honor, an honorary doctorate, to Jacques Derrida. Among the many opposing voices was a letter to *The Times*, which said that Derrida's "work does not meet accepted standards of clarity and rigour." His writings "seem to consist in no small part of elaborate jokes and puns ('logical phallusies' [*sic*] and the like)." He has been "making a career out of what we regard as translating into the academic sphere tricks and gimmicks," and "where coherent assertions are being made at all, these are either false or trivial," all of which are not "sufficient grounds for the awarding of an honorary degree in a distinguished university."[43] Among the eighteen signatories was the name René Thom. If there is a binary, it is hard to see which side Thom is on.[44]

Postmodernism has many features that I find unattractive. Large swathes of it seem to be arrogant and pompous, and much of it—like the "matheme"—seems almost meaningless. And by playing with the very meaning of "meaning," it ties me in knots when I try to write about it and about Thom's interaction with it. But it seems to be correct that there is no Grand Narrative. There is not one story and there are more than two sides.

This has been easily the most difficult chapter to write. I am conscious of the rock-star status accorded to Lacan in 1960s Paris, and I recognize that many find subtlety, nuance, and originality in the works of Deleuze, Guattari, and the others. And even if I could masterfully construct a dialectic to moderate between postmodernism and science, there are still too many alternative perspectives. This chapter is not—like Galileo's—a *Dialogue Concerning the Two Chief World Systems*, and even though I expect that almost everyone will object to something I have written here, I trust that it is not sufficiently polarizing as to end up in anyone's Index of Forbidden Books, the *Index Librorum Prohibitorum*.

There is no objective biography of Thom, his views, and their relationship to those of the people around him. The words on this and previous pages are just signs, marks on paper, a text made by me.

René Thom died on 25 October 2002.

Dalí

Over the course of seven decades, from 1910 to 1983, the output of the deliberately outrageous Spanish surrealist Salvador Dalí was prodigious, with around two thousand major paintings that touched upon almost every conceivable subject matter. Given such a vast portfolio, it is easy to find swallows, butterflies, and ambiguities among all the topologically contorted nudes and thereby claim that catastrophe theory has something to say about it all. However, the connection runs much deeper because Dalí met Thom, and the two got on famously.

In 1982–83, some four years after their first meeting, Dalí painted around twenty works on the theme of catastrophe theory. Throughout his life, Dalí had taken an interest in science, and many of his famous works have references to quantum mechanics, general relativity, holography, and the discovery of DNA. However, rather than Dalí's catastrophe paintings being a simple case of an artist rather emptily referring to a piece of science, and adding little, for Dalí this was a major intellectual upheaval that redefined everything he had done and everything he held dear. He went so far as to say, "A more aesthetic notion than the latest theory of Catastrophes by René Thom is still to be found, which can be applied both to the geometry of the parabolic umbilicus and the drift of the continents. René Thom's Theory has bewitched all of my atoms since I first heard about it."[45]

It is not difficult to see how the two would get along so well. Dalí had spent much of his life painting distorted bodies, and Thom was the grand master of rubber-sheet topology.

You can almost hear the thunderclap of poetic resonance as their two worlds collide, worlds of imagination in which a teacup is a doughnut, and the four-dimensional space-time manifold is a pair of buttocks with five lobes. Dalí's bendy-stretchy world would have held few surprises for Thom, and one wonders how a surrealist feels on being told that his deliberately crazy world actually makes a lot of sense.

Dalí's first explorations of the symbolic possibilities of Thom's ideas appear rather innocuously in two unfinished works showing Velazquez's dwarf, Sebastian de Morra, seated in the courtyard of a famously imposing Spanish building, the Escorial, surrounded by squiggles that Dalí refers to as "Catastrophic Signs."

Although Dalí might not have yet fully understood them, he has clearly accepted that, in the eyes of Thom, these markings are loaded with meaning. Dalí takes this further in the twenty-nine-page *Treaty on Catastropheiform Writing*. If

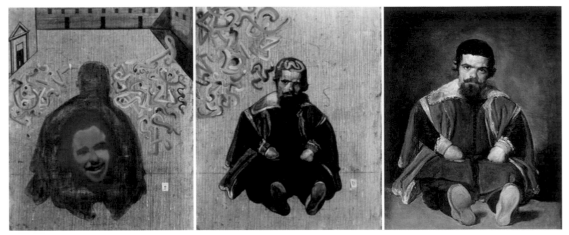

Left: Untitled. After *The Jester Don Sebastián de Morra* by Velázquez in the Courtyard of El Escorial and Catastropheiform Writing, c. 1982 © Salvador Dalí, Fundació Gala-Salvador Dalí, ARS. *Middle*: Untitled. After *The Jester Don Sebastián de Morra* by Velázquez and Catastropheiform Writing, c. 1982 © Salvador Dalí, Fundació Gala-Salvador Dalí, ARS. *Right*: *Portrait of Sebastián de Morra*, Diego Velázquez © Museo del Prado.

the symbols constitute some form of alphabet, then Dalí is trying to form the shapes into words. Dalí could also scarcely fail to notice the resemblance between Thom's swallowtail and the D of Dalí's own signature. Over the years, Dalí's signature had taken many forms, and after meeting Thom, Dalí accentuated the calligraphic resonance.

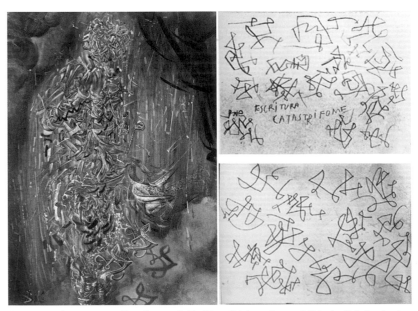

Saint entouré de trois pi-mésons (Saint Surrounded by Three Pi Mesons), 1956, © Salvador Dalí, Fundació Gala-Salvador Dalí, ARS, and two pages from Treatise of Catastropheiform Writing, 1982.

Further paintings from 1982, *Figures, Pieta, Catastrophic Signs* (lower left), *Figure after Michelangelo's "Dawn" on the Tomb of Lorenzo di Medici* (lower right), and *Martyr—Inspired by the Sufferings of Dalí in His Illness* (upper right), suggest that Thom has explained how the outline of the human body is formed from catastrophic shapes. Dalí has painted many thousands of nudes, but here he seems to be looking for Thom's shapes, trying to see what fits where.

Martyr seems to show wave fronts radiating from the body, and there is a cusp surrounded by a fold at center right, almost at a hyperbolic umbilic.

Untitled. After *The Resurrection of Christ* by Michelangelo, c. 1982 © Salvador Dalí, Fundació Gala-Salvador Dalí, ARS.

Untitled. Pieta after Michelangelo and Catastrophei-form Writing, c. 1982 by Salvador Dalí.

Untitled. Dawn after Michelangelo's Tomb of Lorenzo de Medici, c. 1982 © Salvador Dalí, Fundació Gala-Salvador Dalí, ARS.

He ventures into Catastrophic Architecture. One painting shows an ordinary building surrounded by catastrophic calligraphy. The title of another, *Twofold Victory of Gaudi*, acknowledges the blobitecture that dominates the capital of his native Catalonia.

In *Topological Contortion of a Female Figure* and *Topological Contortion of a Female Figure Becoming a Cello* he revisits rubber-sheet topology. Topology and the human form—it is Thom territory.

Escorial and Catastropheiform Calligraphy, c. 1982, Salvador Dalí.

Topological Contortion of a Female Figure, 1983 © Salvador Dalí, Fundació Gala-Salvador Dalí, ARS.

Double Victory of Gaudi, 1982, Salvador Dalí.

Topological Contortion of a Female Figure Becoming a Violoncello, 1983, Salvador Dalí.

Although a minor work, *The Escorial Contorted in Disorderly Fashion and Metamorphosing into a Woman* suggests that Dalí's understanding of catastrophe theory was far deeper than superficial. The typically long-winded title almost says it all.

Take a flat rectangular grillage—such as the facade of the Escorial, a large palace near Madrid that had featured in many of Dalí's earlier works. Then bend and stretch it, and embed it as a 2D-in-3D manifold, such as the smooth, curved skin of a woman, albeit a topologically contorted one. Then project the 3D space, manifold included, down to 2D—that is, paint it on a flat piece of canvas. It is the classic setup for singularity theory. And there is even a swallowtail on the waist.

Perhaps I am reading too much into this painting, but it seems to me that all the signs are there that Dalí knows it is "chart, manifold, projection." His later paintings, as we shall see, also allude to charts.

Paintings in 1982 of Michelangelo's *Creation* and of the Medici Tomb show muscular bodies of Adam, *Dawn*, and *Evening*. Later paintings show the bodies of *Dawn* and *Evening* draped in catastrophic squiggles. *Evening* is placed in the courtyard of the Escorial. Then, finally, the Escorial itself becomes the reclining nude, a topologically distorted one.

Architectural Contortion of El Escorial, c. 1982, Salvador Dalí.

Untitled. Dusk after Michelangelo's Tomb of Lorenzo de Medici, c. 1982 © Salvador Dalí, Fundació Gala-Salvador Dalí, ARS.

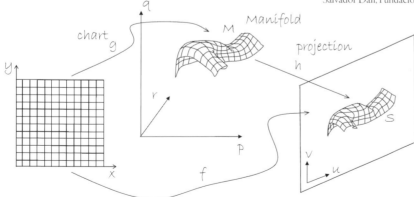

Dalí's explicit acknowledgment to Thom comes with *Topological Detachment of Europe: Homage to René Thom*. It shows a large crack running through the center of France and is said to be a response to a comment by Thom that the tectonic plate beneath Europe rotates about Perpignan. For reasons known best to Dalí himself, and somehow related to the fact that he seemed to have good ideas—revelations even—as he approached it, Dalí had long ago decided that Perpignan Railway Station was the center of the Universe, and it figures in many of his earlier works.

In the bottom corner, the equation for the swallowtail is transcribed exactly as it appears in *Structural Stability and Morphogenesis*.

A female form is discernible in the blue shaded background—perhaps another indication that Dalí associates Thom's theory with the bodyscape, perhaps a reference to the shroud of his beloved wife, Gala, who died the previous year. The painting falls decidedly in the genre of the Burkean Sublime, invoking the usual literal—rather than the mathematical—meaning of the word "catastrophe," a foreboding portent of cataclysm and disaster.

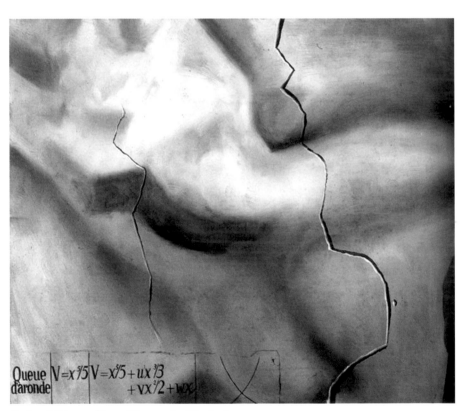

Topological Abduction of Europe (Homage to René Thom), 1983.

The year is 1983. Dalí is an old man, riven with Parkinson's disease. His beloved wife is dead. A few years earlier Dalí had met Thom and had been profoundly impressed. As Dalí put it:

> Everything I do from now on will be devoted to the phenomenon of catastrophes. Now it is no longer a matter of pure imagination, of my moods and dreams, of automatism. Now I am painting the meaning that derives from my existence, my illness or my vital memories.[46]

Doubtless with the help of an assistant, Dalí paints his final picture, *The Swallow's Tail*. It is an unappreciated masterpiece of understatement. In a few simple yet iconic strokes, it brings together all the themes of this book. It has a swallowtail at the center, and across it lies the twice-folded S. There is a rip at the upper fold, from where a vertical line falls from the precipice of our ski slope.

The background is pegged out like a chart—blue and clothlike, like a shroud, with the bust of a female, arms upraised, discernible beneath. There is a cello and a number of S-shaped cello sound holes.

From the photograph, it is clear that the painting is important to him.

Dalí, Marquis de Púbol, in his castle with his last painting, Swallow's Tail and Cellos (Catastrophe Series), March 1983. Photo Robert Descharnes / © Descharnes & Descharnes sarl 2017.

Untitled. Swallow's Tail and Cellos (Catastrophes Series), 1983 © Salvador Dalí,
Fundació Gala-Salvador Dalí, ARS.

The following year Dalí suffers severe burns in a fire at his castle. He lives for another five years, dying of heart failure in January 1989.

The painting still stands on an easel in the castle, and each year many thousands pass it by with little recognition of what it means.

Hogarth, in his *Analysis*, had selected two lines as being of special significance—the flat S-shape, his Line of Beauty, and the spiraling helical space curve, his Line of Grace.

There is no evidence that Dalí was deliberately emulating Hogarth, but even so, the final effect is the same. Dalí, too, has selected two curves. His final words on Art spoke of Thom's theory as being an "aesthetic notion," one that was "unsurpassed." This final picture is Dalí's realization of that notion.

Remarkably, the picture somehow captures the twofold nature of catastrophe theory that has been developed in this book, with its bittersweet threads of Downfall and Beauty. The Downfall is obvious, even from the word "catastrophe," but the Beauty is not.

Dalí has learned to see swallowtails on the waistline of his nudes and his wife. The blue skies above his castle are filled with swallows darting and swooping freely and vivaciously. The swallowtail lines denote Life. This is his Outline of Beauty.

This thread is reinforced by the cello, readily identifiable as feminine beauty from his previous work where a female figure is topologically contorted to become a cello, a variant on the long-established theme that the stringed instruments have a feminine form, most famously realized by Man Ray's *Le Violon d'Ingres*.

The edges of the cello are cusped, architecturally. The sound holes are curvaceous S-shapes. They are also integral signs in mathematics, bringing positive overtones of integration, perhaps with Gala in the hereafter.

The two central sound holes signify Dalí himself, via his hallmark moustache. He has done this before, in another 1983 painting, *Untitled—Head of a Spanish Nobleman, Fashioned by the Catastrophe Model from a Swallow's Tail and Two*

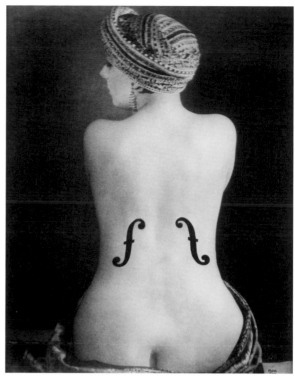

Le Violon d'Ingres (Ingres's Violin) © Man Ray Trust / Artists Rights Society (ARS), NY / ADAGP, Paris 2017.

Halves of a Cello, where the elements of the final work can be seen to be gathering.

The thread of Downfall is the twice-folded wave. This is catastrophe as cataclysm, collapse, even Death. The theme is clear—the rip at the upper fold, the centrally placed vertical fall from the precipice, and the shroud behind.

But even within this theme of collapse and decay, there are elements of positivity. There is a vertical line from the other fold, from where upward jumps are possible. And the woman behind the shroud has her arms aloft, as if in joyous transcendence beyond the curtain of Death, for Gala and soon for Dalí.

Dalí's final painting is about Downfall and it is about Beauty. His curves have pregnance. He is not just emptily painting equations. In one painting, Dalí rewrites Hogarth's *Analysis*, and with a few strokes of the brush, he says more than all the words in this book.

Sketches by Dali on his copy of *Paraboles et Catastrophes* by René Thom © Salvador Dalí, Fundació Gala-Salvador Dalí, ARS.

One weekend my wife and I went to Dalí's museum in Figueres and his castle in Púbol. At the museum, we managed to persuade the custodians to allow us access behind the scenes, into Dalí's private library.

There on the bookshelf, beside his bed, is a copy of *Paraboles et Catastrophes* by René Thom. We are allowed to take it down. It seems like we are perhaps the first to do so since Dalí died.

The front page is signed. It translates as

To the Master,
I hope this reaches you in time,
René Thom,

It is dated 22 November 1983.

Remarkably, Dalí has covered many pages with sketches, line drawings of nudes. It is remarkable because Thom makes no mention—in that or in any book—of the connection between catastrophe theory and life drawing.

There is also a sketch of a phoenix rising, wings aloft, from the body of a dead lion. Despite the shaking hand of Parkinson's, it is an undeniably positive image.

Another drawing, facing the contents page, shows a nude with arms aloft, leaping in joyous rapture. For me, it is one of Dalí's finest works. It is perhaps his very last.

"Hooray!" said the nude. "At last, a bit of understanding." Sketch of joyous nude female by Dalí, on his copy of *Paraboles et Catastrophes* by René Thom © Salvador Dalí, Fundació Gala-Salvador Dalí, ARS.

Thom closes *Structural Stability and Morphogenesis* with the thought:

> At a time when so many scholars in the world are calculating, is it not desirable that some, who can, dream?

I hope that, via the flat, rectangular pages of this book, I have managed to convey something of the idea-hoard that is René Thom's Big Picture. That it is rigorous mathematics with many applications in the sciences is undeniable, but I have also tried to suggest that it has something to say about Art, and you may or may not accept this. We have traced this final connection, my own, connecting catastrophe theory to Beauty, on a thread running from Hogarth, Burke, and Queen Caroline through to Hollinghurst, Gabo, and Dalí with many points in between. It may be a slightly crazy idea, but if I am mad, then so was Salvador Dalí.

Notes

The source of the book epigraph is the following: Catalogo de la exposicion Dalí Grafista, texto de Montse Aguer, DAS edicions, Figueres, Spain, 2003.

1. Every theory builds on the work of others, and a full attribution for the development of catastrophe theory should include acknowledgments of the contributions of mathematicians such as Henri Poincaré, Hassler Whitney, and Vladimir Arnol'd.

2. Paul Klee, *Pedagogical Sketchbook* (London: Faber and Faber, 1953), 16.

3. The line on the body corresponding to the line on the sketch pad is often called the *apparent contour*. We choose to call it the *lifted outline* to avoid any confusion with more usual meanings of the word "contour." For the purposes of this book, the main thing is to be aware that there are two distinct lines—one on the pad and one on the body.

4. René Thom, *Structural Stability and Morphogenesis* (Reading, MA: W. A. Benjamin, 1975), 41.

5. Ibid, 10.

6. D'A. W. Thompson, *On Growth and Form*, abr. ed. (Cambridge: Cambridge University Press, 1961), 72–73.

7. René Thom, *Structural Stability and Morphogenesis* (Reading, MA: W. A. Benjamin, 1975), 11, 319, 316, 330.

8. J. Roorda, "Stability of Structures with Small Imperfections," *Journal of the Engineering Mechanics Division ASCE* 91 (1965): 87.

9. A. Hollinghurst, *The Line of Beauty* (London: Picador, 2004), 200.

10. My wife and I once had the pleasure of staying off-season in a very swish hotel in Spain (see final chapter). Shortly after arriving at our room, I emerged from the bathroom, proclaiming, "Darling, there's a wigwam in the bidet!" In the bathrooms of luxurious establishments, the combination of bright overhead spotlights and smoothly mirrored surfaces can lead to a rich variety of catastrophe optics (chapter 11).

11. In the unpublished manuscript, Clint McCrory proves the existence of two forms of the gulls transition—a hyperbolic and an elliptic variant.

12. I am grateful to Dr. Joan Lasenby, Michael Burke, and Stuart Bennett of Cambridge University Engineering Department Signal Processing Group for the experimental data acquisition.

13. Michael Berry has suggested that Thom is unlikely to have seen *elliptic* umbilics in his rather elementary optical experiments, and that this would have been puzzling, given that the mathematics states that these should occur as stable singularities of caustics. A quantitative statistical explanation for the rareness of elliptic umbilics is presented in M. V. Berry and J. H. Hannay, "Umbilic Points on Gaussian Random Surfaces," *Journal of Physics A: Mathematical and General* 10, no. 11 (1977): 1809–21.

14. Further details of the folding caused by reflection from a rippling surface can be found in M. Longuet-Higgins, "Reflection and Refraction at a Random Moving Surface, I–III," *Journal of the Optical Society of America* 50 (1960): 838–56; M. V. Berry and C. Upstill, "Catastrophe Optics: Morphologies of Caustics and Their Diffraction Patterns," *Progress in Optics* 18 (1980): 257–346; and J. F. Nye, *Natural Focusing and Fine Structure of Light* (Bristol: Institute of Physics Publishing, 1999).

15. M. V. Berry, J. F. Nye, and F. J. Wright, "The Elliptic Umbilic Diffraction Catastrophe," *Philosophical Transactions of the Royal Society of London* 291 (1979): 453–84. For further details, see also Nye, *Natural Focusing and Fine Structure of Light*.

16. The secondary rainbow is produced by a small proportion of the light that undergoes a further reflection inside the raindrop. This light sheet is also folded, with the fold emerging at around 51 degrees. Michael Berry pointed out that the photograph also shows supernumerary fringes on the inner side of the main bow that can only be explained by considering the wave nature of light.

17. For further details on gravitational lensing, see J. Wambsganss, "Gravitational Lensing in Astronomy," *Living Reviews in Relativity* 1 (1998): 12.

18. Microlensing is only one of many ways to locate exoplanets. Others include Doppler methods and even direct imaging.

19. Immanuel Kant, *Critique of the Power of Judgment*, in *Cambridge Edition of the Works of Immanuel Kant*, ed. Paul Guyer, trans. Paul Guyer and Eric Matthews (Cambridge: Cambridge University Press, 2000), 90.

20. Thom, *Structural Stability and Morphogenesis*, 193.

21. Oscar Niemeyer, *Poem of the Curve*, © 2016 Artists Rights Society (ARS), New York/AUTVIS, Sao Paulo.

22. Frank Gehry is often cited as a blobitect, although some definitions of blobitecture—based on whether designs originate from computer or physical models—do not include him. However, I do not include his most famous works in this book because although the surfaces of buildings such as the Bilbao Guggenheim are folded, they are also creased and thus not smooth. The apparent "cusps" are thus largely "architectural cusps" that exist on the building rather than the catastrophic cusps that only exist on photographs and retinas.

23. René Thom, *Semiophysics: A Sketch*, trans. Vendla Meyer, Advanced Book Program (Redwood City, CA: Addison-Wesley, 1990), 3.

24. Ibid., 6.

25. E. H. Gombrich, *Art and Illusion*, 6th ed. (London: Phaidon, 2002), 87.

26. Giovanni Pico della Mirandola, *Oration on the Dignity of Man* (1486).

27. Giorgio Vasari, *Lives of the Most Excellent Painters, Sculptors and Architects* (1550, in Italian), part 4.

28. Kenneth Clark, *The Nude* (1956; reprint, New York: Pelican/Penguin, 1970), 241, 242.

29. Hollinghurst, *The Line of Beauty*, 243.

30. *Six Fois Deux*, part 5B: René(e)s (1976), 52:56 min.

31. René Thom, "Espaces fibrés en sphères et carrés de Steenrod," *Annales scientifiques de l'École normale supérieure* 69 (1952): 109–82.

32. René Thom, "Quelques propriétés globales des variétés différentiables," *Commentarii Mathematici Helvetici* 28 (1954): 17–86.

33. Raphael S. Zahler and Hector J. Sussmann, "Claims and Accomplishments of Applied Catastrophe Theory," *Nature* 269 (27 October 1977): 759–63, doi:10.1038/269759a0; Hector J. Sussmann and Raphael Zahler, "Catastrophe Theory as Applied to the Social and Biological Sciences," *Synthèse* 37, no. 2 (1978): 117–216.

34. Stephen Smale, review of *Catastrophe Theory: Selected Papers, 1972–1977* by E. C. Zeeman, *Bulletin of the American Mathematical Society* 84, no. 6 (1978): 1360–68.

35. In 1961, the Poincaré conjecture was one of mathematics' most challenging unsolved problems. It concerns the equivalence or otherwise of topological objects, and can be very loosely stated as: any finite three-dimensional object without holes or boundary is equivalent to a three-dimensional sphere. It was originally stated around 1900 by the great French mathematician Henri Poincaré. Smale's 1961 proof for the higher-dimensional cases was a major breakthrough. The full conjecture has now been proven to be true by Grigory Perelman, based heavily on work by Richard Hamilton.

36. Vladimir I. Arnol'd, *Catastrophe Theory*, 3rd ed. (Berlin: Springer-Verlag, 1992), 102–3. Hassler Whitney (1907–1989) was an American mathematician whose work laid the foundations of singularity theory. We encounter the Whitney Umbrella in chapter 10.

37. More constructively, M. V. Berry ("In Support of Catastrophe Theory," *Nature* 270 [1977]: 382–83) presented a threefold description of "application, illustration, invocation." Application and illustration involved fields where catastrophe theory had led to either genuine advances or illuminating new perspectives on known results, catastrophe optics and elastic stability being examples. Invocation was where catastrophe theory provided useful metaphors through the suggestive power of its images, in fields such as the life sciences where there was no preexisting or accepted mathematical framework, with Berry's letter concluding that "perhaps it is towards this area that Zahler's and Sussmann's criticisms are really directed."

38. René Thom, *Prédire n'est pas expliquer* (Paris: Flammarion, 1993), 132.

39. Jacques Lacan, "L'Étourdit," *Scilicet* 4 (1973): 5–52, English translation here by Alan Sokal and Jean Bricmont, *Intellectual Impostures* (London: Profile Books, 1998), 31.

40. Jacques Lacan, "The Signification of the Phallus" (lecture at the Max Planck Society, Munich, 1958), text reproduced in *Écrits*, trans. Bruce Fink (New York: W. W. Norton, 2006), 581.

41. Jean-François Lyotard, *The Postmodern Condition: A Report on Knowledge*, trans. Geoff Bennington and Brian Massumi (Minneapolis: University of Minnesota Press, 1984); see also Sokal and Bricmont, *Intellectual Impostures*, 127–28.

42. René Thom, "Halte au hasard, silence au bruit," in *Le Débat, La Querelle du Déterminisme* (Paris: Gallimard, 1990).

43. "From Professor Barry Smith and Others," *The Times*, May 9, 1992.

44. Michael Berry states: "After several conversations with René Thom, I came to think that he fundamentally misunderstood science. Whatever he understood, he regarded as trivial, and whatever he did not understand, he considered profound. But this disjunction is misleading: science operates precisely by expanding the boundary between the trivial and the profound; we proceed little by little, understanding what we can. I think it gets to the heart of why Thom had such difficulty communicating with physicists and biologists" (personal communication with the author).

45. Catalogo de la exposicion Dalí Grafista, texto de Montse Aguer, DAS edicions, Figueres, Spain, 2003.

46. R. Descharnes and G. Neret, *Dali: The Paintings* (Cologne: Taschen, 2001), 722.

Bibliography

Arnol'd, Vladimir I. *Catastrophe Theory*. 3rd ed. Berlin: Springer-Verlag, 1992.

Burke, E. *A Philosophical Enquiry into the Origins of Our Ideas of the Sublime and the Beautiful*. 1757.

Clark, Kenneth. *The Nude*. 1956. Reprint, New York: Pelican/Penguin, 1970.

Descharnes, R., and G. Neret. *Dali: The Paintings*. Cologne: Taschen, 2001.

Gombrich, E. H. *Art and Illusion*. 6th ed. London: Phaidon, 2002.

Hammer, M., and C. Lodder. *Constructing Modernity: The Art and Career of Naum Gabo*. New Haven: Yale University Press, 2000.

Hogarth, W. *The Analysis of Beauty*. 1753.

Hollinghurst, A. *The Line of Beauty*. London: Picador, 2004.

Kant, Immanuel. *Critique of the Power of Judgment*. 1790. In *Cambridge Edition of the Works of Immanuel Kant*, ed. Paul Guyer, trans. Paul Guyer and Eric Matthews. Cambridge: Cambridge University Press, 2000.

Klee, Paul. *Pedagogical Sketchbook*. London: Faber and Faber, 1953. German edition, 1925.

Lacan, Jacques. "L'Étourdit." *Scilicet* 4 (1973): 5–52.

———. *Le Sinthome* (The Symptom). Circa 1975.

Laland, K. N., and G. R. Brown. *Sense and Nonsense: Evolutionary Perspectives on Human Behaviour*. Oxford: Oxford University Press, 2002.

Lyotard, Jean-François. *The Postmodern Condition: A Report on Knowledge*. Trans. Geoff Bennington and Brian Massumi. Minneapolis: University of Minnesota Press, 1984. First published in French in 1979.

Mandelbrot, Benoit. *The Fractal Geometry of Nature*. New York: W. H. Freeman, 1982.

Niemeyer, O. *The Curves of Time*. London: Phaidon, 2000.

Nye, J. F. *Natural Focusing and Fine Structure of Light: Caustics and Wave Dislocations*. Bristol: Institute of Physics Publishing, 1999.

Pico della Mirandola, Giovanni. *Oration on the Dignity of Man*. 1486.

Pomian, Krzysztof, dir. *La Querelle du déterminisme: Philosophie de la science d'aujourd'hui*. Paris: Gallimard, 1990.

Poston, T., and I. Stewart. *Catastrophe Theory and Its Applications*. London: Pitman, 1978.

Smale, Stephen. Review of *Catastrophe Theory: Selected Papers, 1972–1977* by E. C. Zeeman, *Bulletin of the American Mathematical Society* 84:6 (1978): 1360–68.

Sokal, Alan, and Jean Bricmont. *Intellectual Impostures*. London: Profile Books, 1998. First published in French in 1997 by Éditions Odile Jacob, Paris.

Sussman, Hector J., and Raphael Zahler. "Catastrophe Theory as Applied to the Social and Biological Sciences." *Synthèse* 37:2 (1978): 117–216.

Thom, René. "Espaces fibrés en sphères et carrés de Steenrod." *Annales scientifiques de l'École normale supérieure* 69 (1952): 109–82.

———. *Paraboles et Catastrophes*. Paris: Flammarion, 1980.

———. *Prédire n'est pas expliquer*. Paris: Flammarion, 1993.

———. "Quelques propriétés globales des variétés différentiables." *Commentarii Mathematici Helvetici* 28 (1954): 17–86.

———. *Semiophysics: A Sketch*. Trans. Vendla Meyer. Advanced Book Program. Redwood City, CA: Addison-Wesley, 1990. French edition, 1988.

———. *Structural Stability and Morphogenesis*. Reading, MA: W. A. Benjamin, 1975. French edition, 1972.

Thompson, D'Arcy. *On Growth and Form*. Cambridge: Cambridge University Press, 1966.

Thompson, J. M. T. *Instabilities and Catastrophes in Science and Engineering*. Chichester: Wiley, 1982.

Thompson, J. M. T., and G. W. Hunt. *Elastic Instability Phenomena*. Chichester: Wiley, 1984.

Vasari, Giorgio. *Lives of the Most Excellent Painters, Sculptors and Architects*. 1550, in Italian.

Wilson, E. O. *Sociobiology: The New Synthesis*. Cambridge, MA: Harvard University Press, 1975.

Zahler, Raphael S., and Hector J. Sussman. "Claims and Accomplishments of Applied Catastrophe Theory." *Nature* 269 (27 October 1977): 759–63. doi:10.1038/269759a0.

Zeeman, E. C. *Catastrophe Theory: Selected Papers, 1972–1977*. Reading, MA: Addison-Wesley, 1977.

Image Credits

Page 69 (bottom right): Photo by Hedges.

Page 71 (right): Brett Weston, *Untitled (Underwater Nude)*, circa 1979 © The Brett Weston Archive, brettwestonarchive.com.

Page 72: Photos courtesy of Michael Berry.

Page 73 (top): Leonardo da Vinci, Notebook (The Codex Arundel) MS 263. folio 87v. British Library/Granger, NYC. All Rights Reserved.

Page 75 (top): Photograph by Professor Roy L. Bishop, *Notes and Records of the Royal Society of London*, 36:1, 1–11, August 1981.

Page 78 (bottom left): NASA, ESA, S. Rodney (John Hopkins University, USA) and the FrontierSN team; T. Treu (University of California Los Angeles, USA), P. Kelly (University of California Berkeley, USA), and the GLASS team; J. Lotz (STScI) and the Frontier Fields team; M. Postman (STScI) and the CLASH team; and Z. Levay (STScI).

Page 79 (center left): Brown University.

Page 79 (bottom left): Brown University.

Page 79 (center right): NASA/ESA/M.J. Jee and H. Ford (Johns Hopkins University).

Page 79 (bottom right, left side): Jean Surdej, Institut d'Astrophysique, Université de Liège, Avenue de Cointe 5, B-4000 Liège, Belgium.

Page 80: NASA/ESA/M.J. Jee and H. Ford (Johns Hopkins University).

Page 81 (top): Courtesy of Bell Labs/Lucent Technologies.

Page 81 (bottom): Courtesy of J. P. Kneib, Caltech.

Page 82: Illustration from "Gravitational Lensing: A Trick of Light" by Frank O'Connell and Jim McManus © The New York Times, December 29, 1998.

Page 84 (bottom): Courtesy of D. P. Bennett, Notre Dame.

Page 91 (right): From the "Virtual Foliage" page at the University of Wisconsin http://www.wisc.edu/botany/virtual.html.

Page 92: Courtesy of James Keener.

Page 94: Detail of cup depicting athletes, revellers, a youth at krater, and a youth inside a bell-krater. Clay, red-figured, diameter 0.34 m, height 0.125 m, width 0.426 m, diameter 0.105 m, 510–500 B.C. Production Place: Athens. Find Spot: Vulci, Etruria. Archaic Period. © The Fitzwilliam Museum, Cambridge.

Page 95 (top): *The Toilet of Venus* ("The Rokeby Venus"), 1647–51, Diego Velázquez © National Gallery, London / Art Resource, NY.

Page 95 (center): Roy Lichtenstein, *De Denver au Montana, Départ 27 Mai 1972*, 1992 © Estate of Roy Lichtenstein/DACS 2016.

Page 95 (bottom left): William-Adolphe Bouguereau, *The Nymphaeum*, 1878 © The Haggin Museum, Stockton, California.

Page 95 (bottom right): Roy Lichtenstein, *Two Nudes*, 1994 © Estate of Roy Lichtenstein/DACS 2016.

Page 96: Henri Matisse, *Dance*, 1910 © 2017 Succession H. Matisse / Artists Rights Society (ARS), New York.

Page 97 (top): Lucien Clergue, *Nu de la Plage, Camargue*, 1964 © Atelier Lucien Clergue.

Page 97 (bottom left): André Kertész, *Distortion # 141*, Paris, 1933 © Estate of André Kertész/Higher Pictures.

Page 97 (bottom right): Edward Weston, *Pepper No. 30* (1930) © Estate of Edward Weston. Collection Center for Creative Photography © 1981 Center for Creative Photography, Arizona Board of Regents for Photography.

Page 98: Helmut Newton, *Saddle I, Paris*, 1976 © The Helmut Newton Estate / Maconchie Photography.

Page 100 (top left): The *Venus Callipyge*, also known as the *Aphrodite Kallipygos*. © National Archaeological Museum of Naples.

Page 100 (top middle): Michelangelo Buonarroti (1475–1564). *Aurora*. Detail from the Tomb of Lorenzo Medici, Duke of Urbino. Post cleaning. Medici Chapels (New Sacristy) © Scala / Art Resource, NY.

Page 100 (top right): Detail of Michelangelo's *David*, Galleria dell'Accademia.

Page 100 (center left): Auguste Rodin, *Danaïd*, 1889 © Musée Rodin.

Page 100 (center right): Courtesy of David Begbie MRBS. *Venii II On Blue*, 2005, steel panel sculpture, edition of 9.

Page 100 (bottom left): Reproduced by permission of The Henry Moore Foundation.

Page 100 (bottom right): Reproduced by permission of The Henry Moore Foundation.

Page 101: Reproduced by permission of The Henry Moore Foundation.

Page 102: Detail from *The Unilever Series: Marsyas*, 2002–3, Anish Kapoor (1954–). Photo © Anish Kapoor. All Rights Reserved, DACS, London/ ARS, NY 2016.

Page 102: Detail from *Untitled*, Anish Kapoor, 1996 (Malmo Konsthall 1996/1997). Photo: Gerry Johansson © Anish Kapoor. All Rights Reserved, DACS, London/ ARS, NY 2016. Courtesy of Gerry Johansson.

Page 103 (top left): Oscar Niemeyer, "Untitled (Girl lying down/ Niteroi)" © 2016 Artists Rights Society (ARS), New York / AUTVIS, São Paulo.

Page 103 (top middle): Oscar Niemeyer, "Untitled (Four females on beach)" © 2016 Artists Rights Society (ARS), New York / AUTVIS, São Paulo.

Index

Page numbers in italics refer to figures.